Painting Animals in Gouache

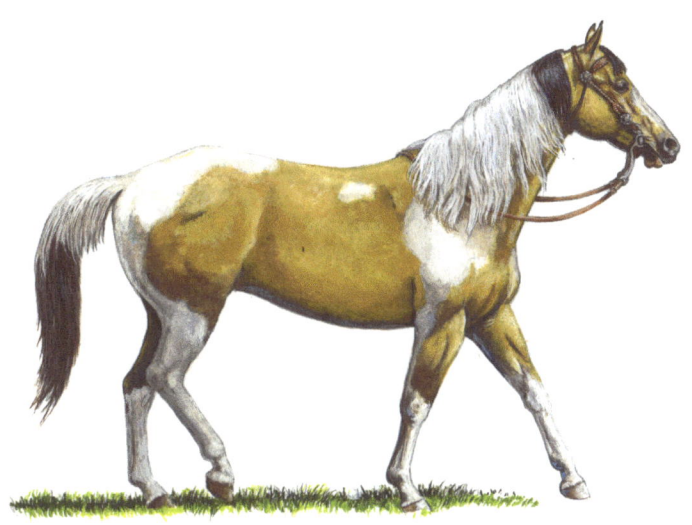

Written and Illustrated
by
Sandy Williams

© Sandra L. Williams 2012

Painting Animals in Gouache
Index

Introduction	1
Gouache	2
Materials List	3
Before You Begin (Health and Safety)	4
Colors and Values	5
Blending Exercise -- Fur and Hair	6
Blending Exercise - Cougar Eyes	7
Getting Started	8
Notes	9
Soft Brown Rabbit	10
Notes	17
Raccoon	18
Pinto Trail Horse	32
Wrapping Things Up	45
Notes	46

Introduction

We've been depicting animals in our art since prehistoric times. Bison and deer dance across the cave walls in Lascaux. Cats, horses and birds bejewel the walls of Egyptian homes and tombs. The paintings of Landseer in the 19th century are embedded in the English culture. And our fascination with animal art continues today.

I've always loved painting animals, all kinds, and I ultimately settled on gouache as my main medium because I can capture every little detail of fur and flashing eyes. I hope I can guide you and inspire you to paint the creatures we see around us.

In this class I demonstrate how to use gouache to paint three very different types of animals: a soft brown Rabbit with long fur under its chin, a Raccoon with rough fur of different colors and a Pinto Trail Horse with a sleek, spotted coat and flowing mane and tail. You'll learn a lot about gouache techniques as you work on these three paintings.

Please note that for the purposes of clear demonstrations I've broken the animals down into sections so that we concentrate on one part of the subject at a time. In the real world you probably wouldn't work like this, although, at times, I've finished the head of an animal before I began the body. When you begin your own paintings, experiment and find out what works best for you. You may approach each animal differently. There is no rule that says you have to do every painting the same way every time, or that you have to finish one section before another.

I hope you enjoy exploring gouache and all it can do to help you paint realistic animals!

Wolf

Eastern Cttontail Rabbit

Gouache

Gouache is an opaque watercolor. The pigments are bound by a liquid glue, like Gum Arabic, and white pigment or chalk is added for more opacity. It has an almost suede like finish and lines painted with gouache can be very sharp. The colors can be brilliant or very subtle. It has a centuries old history and has been used for anything from illuminated manuscripts to modern commercial advertising work.

There are many benefit to using gouache. You don't have to deal with the odor, toxicity and slow drying time of oils. Acrylics dry very quickly and can't be reworked, while gouache paintings can be reworked months or even years later.

There are many brands of gouache available. I use mostly Winsor & Newton because it's easy to find and of good quality. Other brands are M. Graham, Holbein, Schmincke and Daler Rowney.

The first time you use gouache squeeze a small amount of color onto your palette. Even though you don't use it all up right away you'll be able to reconstitute it with water for later use. The only time this won't work is when you have a large area to cover. Use fresh paint for that or you'll get little lumps of undisolved paint in yur piece. If that happens brush them off and touch up.

Don't add a lot of water to the paint, or fill up the paint well on your palette with water. Water is added to the paint a little at a time by dipping your brush in water and then working it into one side of your spot of paint. The paint should have a creamy consistency. If you add too much water the paint will lose its opacity. One exeption in these exercises is when we paint an underpainting. In this instance we use a thinner layer of paint to cover the white of the paper before painting the top layers. The colors can be mixed in another well on the palette or, sometimes, directly on the painting.

One of the great advantages of gouache is that it's very "forgiving." If you find that a certain area is not working just paint over it and start again.

Start by squeezing out spots of paint about this size

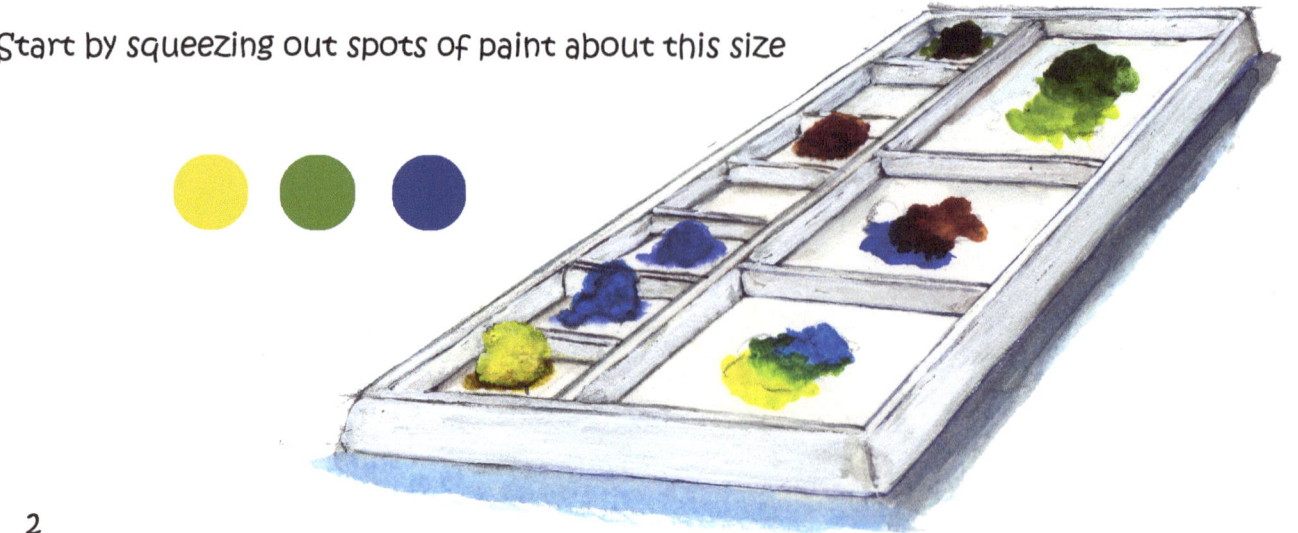

Materials List

PENCILS -- I generally use a softer pencil, like a 4B, to draw with but use whatever you're comfortable with. Just make sure that you don't make your marks so hard that they're hard to erase. I use a kneaded eraser because it won't leave little crumbly bits of material that have to be brushed off.

PAPER -- I recommend using hot press watercolor paper, preferably 140 #, although a little lighter weight would be OK, too. Some artists use illustration board, vellum or bristol. I use Arches 140# hot press because it has a nice, smooth surface to make detailing easier and crisper looking. Experiment and try some different papers. One half standard size sheet should be plenty for this course.

PALETTE -- It should be white so you can see exactly what color you're mixing. If you don't have a palette a white paper plate works fine. It's just a little harder to transport wet paint if you have to move around.

WATER CONTAINER -- Use whatever you have on hand. At home I use 5 ounce disposable Dixie cups or an old cat food contaner (properly washed!)

TRANSFER PAPER -- Depending on how you transfer your images you may or may not need some plain tracing paper. An 11" x 14" sheet folded in half should do.

BRUSHES -- You'll need three very small watercolor brushes: a 4/0 small round, a #1 small round and an 18/0 or 20/0 brush

GOUACHE -- The eight tubes listed here will give you enough variety of colors to complete all the illustrations in this course. The brand I use is Winsor & Newton but that's not a requirement.

- Permanent White
- Olive Green
- Burnt Umber
- Burnt Sienna
- Primary Blue
- Ivory Black
- Ultramarine Blue
- Primary Yellow

Dolphins

Before You Begin

Here are a few tips on health and safety.

BE AWARE! Some of the pigments we work with are poisonous. Visit a site like http://www.ci.tucson.az.us/arthazards for specific information on the pigments or processes you use.

For this course please remember three things.

1. Don't put the tips of your brushes in your mouth!

2. Wash your hands after painting before you eat.

3. Get up and stretch frequently. Besides loosening up your body you'll come back to your painting with fresh eyes and it will be easier to see the progress you've made and what has yet to be done.

Bobcat

White Tail Buck

Red Fox

Colors and Values

A few notes on color:

Color is fleeting, fugitive and ever changing. Colors of animals can change with the type of light, the time of day, reflections from grass, sky, buildings, water, the age of the animal or the time of year. Some animals naturally have different colors in the same species. The raccoon, for instance, can range from gray to reddish brown. So don't stress out if you don't get the color you want "exactly right." In this class you'll be using a limited palette of only eight tubes of gouache, but you'll still be able to realistically depict the animals.

Values:

What you really need to be careful about is value. Value is the lightness or darkness of your paint, and without a good range of values your painting will look a bit boring, without, well . . . sparkle! Some samples of the value scales you'll be using are below.

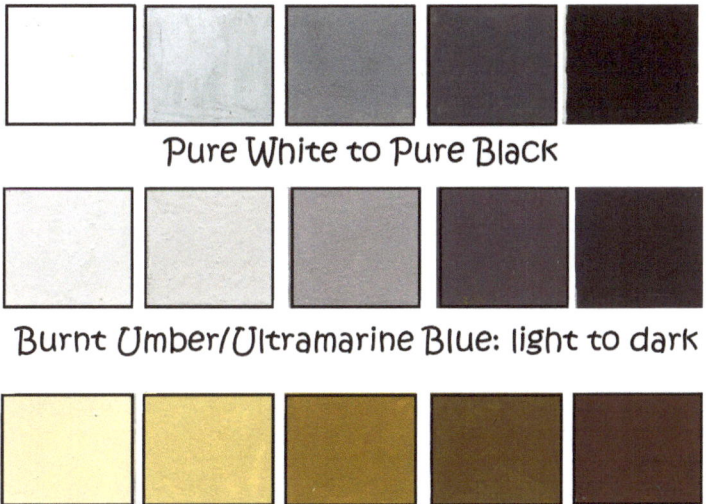

Pure White to Pure Black

Burnt Umber/Ultramarine Blue: light to dark

Yellow Ochre lightened with white and darkened with Burnt Umber

Blending Exercises

I can't stress enough the importance of learning good blending techniques. Without blending your images will look hard edged and not "real." So take some time and practice the exercises on this page. Remember, don't be afraid to "make a mistake." This is a learning experience and an opportunity to check out gouache and push it to its limits to see what it can do. I can show you how I blend the paint, but that doesn't mean that my way is the only way, or even the best way. See what works best for you!

Colors used: Burnt Umber, Ultramarine Blue, Permanent White

Long, Soft Fur

(1)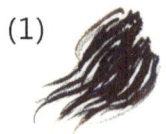

Using a dark mixture of Burnt Umber and Ultramarine Blue, roughly paint in some long, flowing hairs.

(2)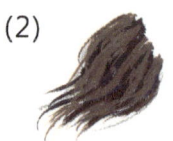

Using a middle value of a mixture of the same colors, paint another layer of hairs.

(3)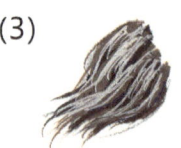

Using pure white paint the top layer of hair. Don't completely cover up the lower layers. Some of the dark should show through.

(4)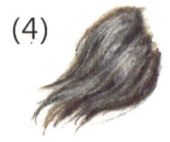

Gently move your damp brush along the hairs to soften the lines. The brown underneath will mix with the white and turn it a light brown. If you lose too much of the white, just add more. Then gently blend again..

Rough Fur

(1)

Use a dark mixture of Burnt Umber and Ultramarine Blue to paint a spot about an inch square. This will be your underpainting.

(2)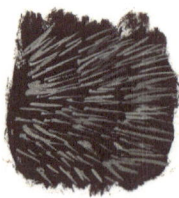

Add a little bit of your dark mixture to White to make a light gray. Paint short strokes, going from left to right, lifting up on the brush at the end of the stroke to make a fine point. Don't make all the strokes the same size or going in the exact same direction.

(3)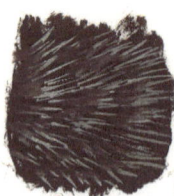

With a slightly damp brush blend in the left side of your strokes where they originate to soften them, leaving the right side sharp. When you blend the color underneath will mix with the White and turn it light brown.

(4)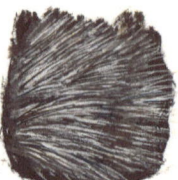

Repeat the layering and blending until you get the effect you want. Then paint one more layer of dark hairs to detail the area.

Blending Exercise -- Cougar Eyes

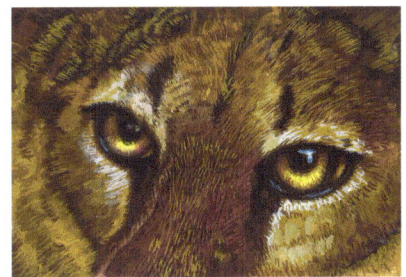
Cougar

When you blend use a damp brush and a light touch. You just want to gently blend enough to take the edge off your strokes and soften them. If you blend too much, just add more gouache and blend again.

Colors used: Ivory Black, Permanent White, Burnt Sienna, Burnt Umber, Yellow Ochre, Brilliant Blue

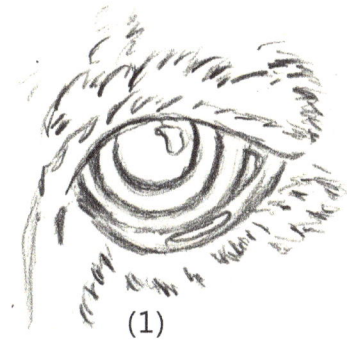
(1)

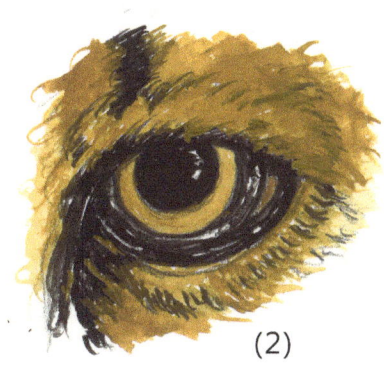
(2)

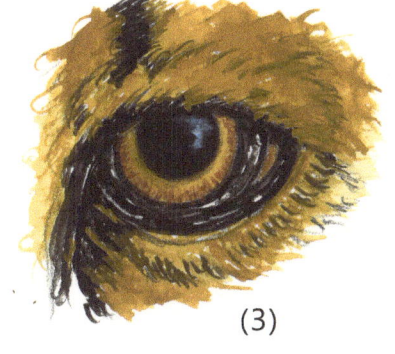
(3)

Transfer this drawing to a small piece of 140# hot press watercolor paper.

With Black, paint over your pencil lines. Paint in the pupil and the dark areas around the eye. Using Yellow Ochre, paint in the iris and the rest of the area around the eye.

To get rid of the hard line between the pupil and iris, use a damp brush to gently blend the areas together. Using Burnt Sienna make tiny lines going from the outside of the iris toward the center of the pupil. Gently blend them into the Yellow Ochre of the iris. With Primary Blue mixed with White, paint the highlight. Blend the edges of the pale blue highlight into the black of the pupil.

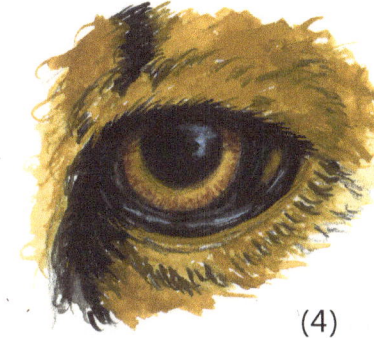
(4)

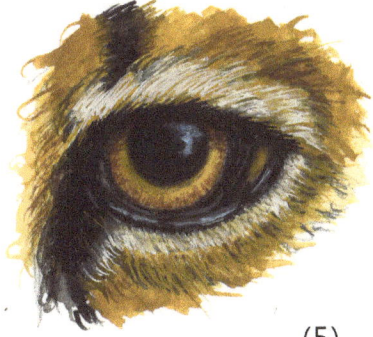
(5)

Using Black, strengthen the lines around the eye and make short strokes going upward at an angle to the right to paint the dark hairs. Using a medium gray (Black mixed with White), paint in the curves below the eye. Blend them in so they're barely noticeable. Put in the highlights along the lower rim of the eye lid with a mixture of Brilliant Blue and White. Gently blend a little. With Burnt Umber shade the top of the iris and blend it down into the Yellow Ochre.

Using thick White gouache, make short strokes above and below the eye, angling to the right. Lift up at the end of your stroke to make a fine point. Using Burnt Umber, make short strokes above and below the white areas, and along the nose on the left side. Gently blend the areas with a damp brush. The Yellow Ochre underneath will bleed into the white so you may have to add more White.

Getting Started

The following three demonstrations show how to use gouache to paint a Soft Brown Rabbit, a Raccoon and a Pinto Trail Horse. Look at each step carefully and read the descriptions. Sometimes you'll be dealing with very small changes that make very big differences in the finished painting. These demonstrations are only guidelines. Feel free to explore the possibilites. Remember, gouache is a very forgiving medium. If you try something and it doesn't seem to be working, you can always paint over it and start again.

At the beginning of each section is a page with a black and white line drawing of the painting. Use this page to transfer the image to your piece of 140# hot press watercolor paper. There are many ways to transfer images. Using a light box is one way, but holding the page up to a window that has sun streaming through it and then putting your watercolor paper over it to trace works just as well. Or, you could put soft graphite (from a soft pencil) on the back of the transfer page, put it directly on top of your watercolor paper and then trace over the lines so they are transferred to your paper that way. I usually keep a piece of tracing paper handy and cover it completely with soft graphite. Then, when I need to transfer an image, I slip it on top of my watercolor paper, graphite side down, and put the page that has the image on it on top. Then I trace the lines to transfer the image. I've used the same piece of tracing paper for over ten years. I just add more graphite to it with a soft 6B pencil when the images get too light. When not in use I keep it folded in half so it doesn't smear all over everything around it.

So. . . get started and enjoy this versatile medium!

Notes

Soft Brown Rabbit

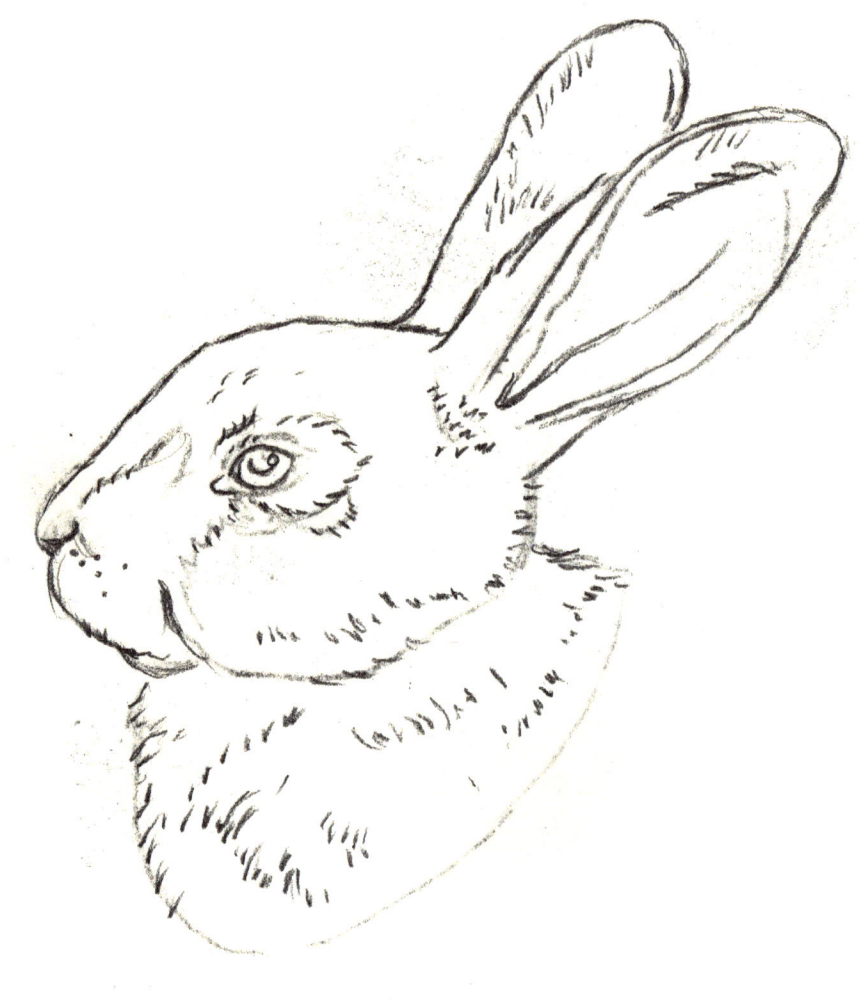

Use this sheet to transfer the image to your sheet of
140# hot press watercolor paper.

The colors used for this project are: Burnt Umber
Burnt Sienna, Permanent White, Ivory Black

Soft Brown Rabbit

Colors: Ivory Black, Permanent White, Burnt Umber and Burnt Sienna

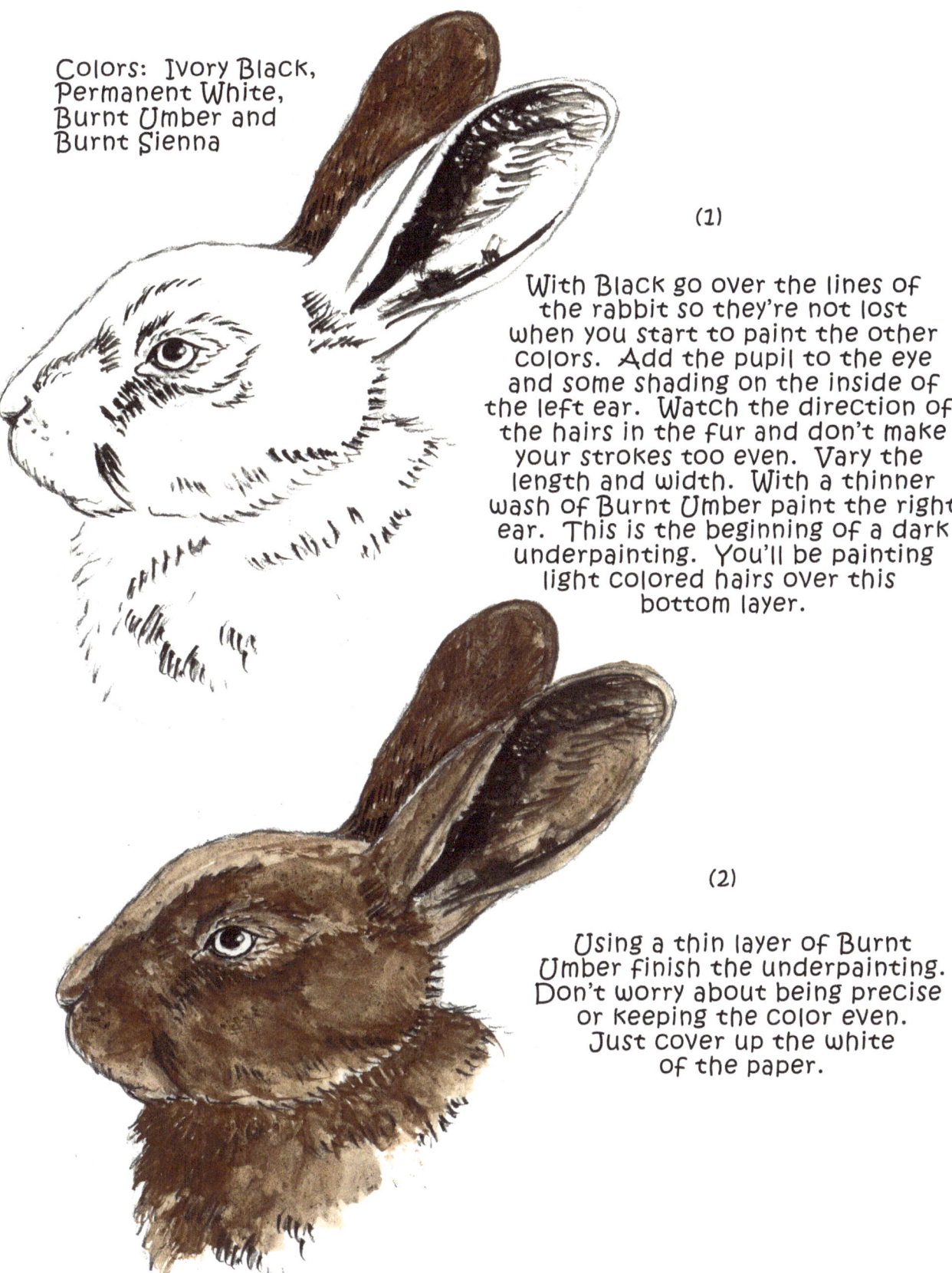

(1)

With Black go over the lines of the rabbit so they're not lost when you start to paint the other colors. Add the pupil to the eye and some shading on the inside of the left ear. Watch the direction of the hairs in the fur and don't make your strokes too even. Vary the length and width. With a thinner wash of Burnt Umber paint the right ear. This is the beginning of a dark underpainting. You'll be painting light colored hairs over this bottom layer.

(2)

Using a thin layer of Burnt Umber finish the underpainting. Don't worry about being precise or keeping the color even. Just cover up the white of the paper.

The Ears Soft Brown Rabbit

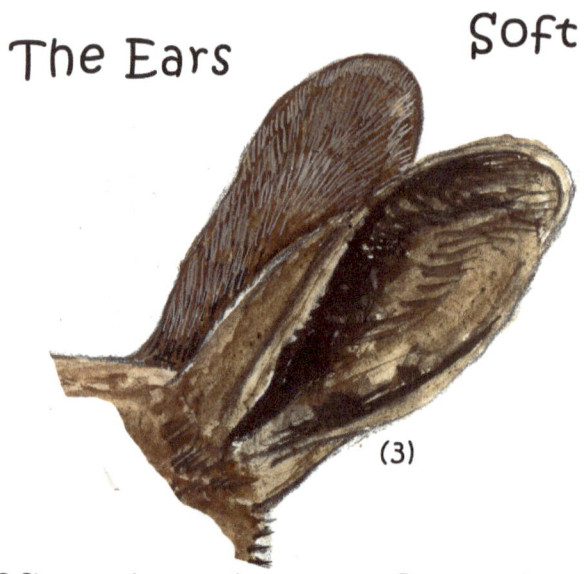

(3)

With a light mixture of Burnt Umber and White begin detailing the right ear. Make short strokes going in the direction of the hairs, lifting up your brush at the end of the stroke to make a narrow point.

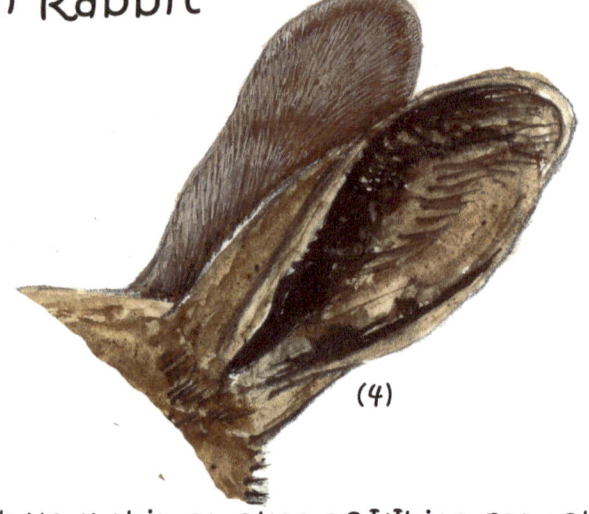

(4)

With very thin strokes of White gouache paint in the light colored hairs. With a damp brush gently blend the strokes. The brown underneath will change the White to a light brown. Be sure to use a damp brush and soften the outside edges of the ear so it won't look pasted on the paper

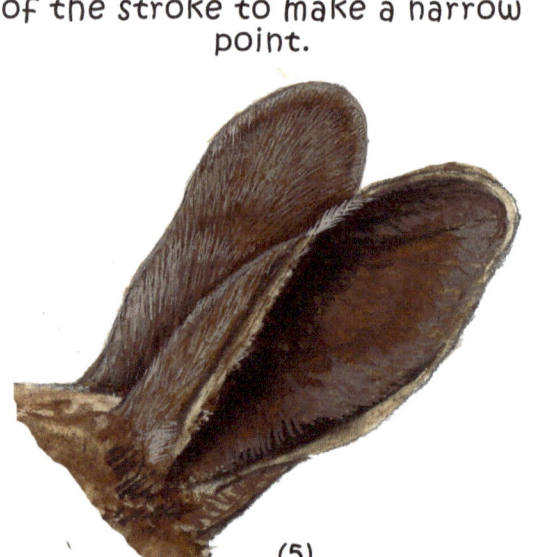

(5)

Begin detailing the left ear by painting the hairs with a thicker layer of a medium value (a mixture of Burnt Umber and White) gouache, making your strokes in the direction of the hairs. Using Burnt Sienna mixed with White paint the skin showing through on the inside of the ear. Blend it into the dark on the left side and the lighter brown on the right side.

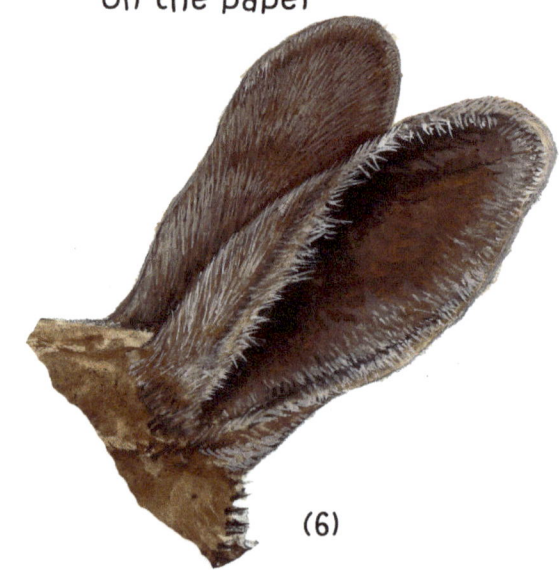

(6)

Using White gouache paint in the lightest hairs. Be sure to lift up on th end of your stroke to make a fine point. If you lose some of your darks just restate them. Make your strokes follow the direction of the hairs. Then, with a damp brush, gently blend a little so the hairs are not so hard edged.

Soft Brown Rabbit

The Eye

These images have been enlarged so it will be easier to see the process.

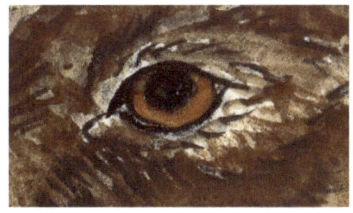

Paint the iris of the eye with a thin layer of Burnt Sienna.
(7)

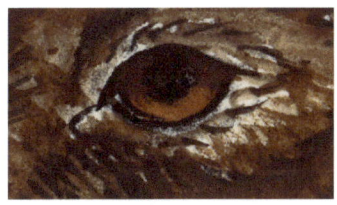

With Burnt Umber paint a shadow across the upper part of the eye, making sure it curves along with the shape of the eye. Blend it into the Burnt Sienna.
(8)

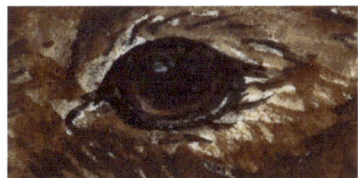

Using Black restate the inside of the pupil. Make sure the black line around the iris is even and makes a good circle. Paint Burnt Umber over most of the Burnt Sienna in the iris and blend it in. Paint a black line below the eye to show the rim of the eye lid. Leave a little white showing above the line where light reflects from it.

(9)

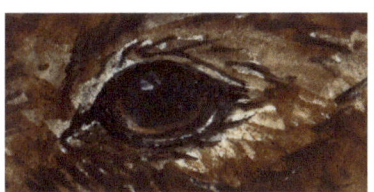

Paint the highlights under the eye on the rim of the eye lid with light gray paint since white would be too glaring. Using the same light gray put the highlights in the pupil. Also put just a touch in the Burnt Sienna of the iris along the bottom left side. Blend.
(10)

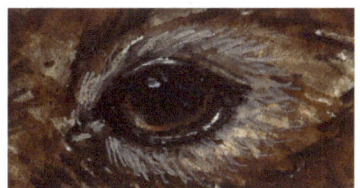

Paint in the light areas of fur above and below the eye with short strokes of White gouache. Blend it in so there aren't hard edges between the black around the eye and the white hairs surrounding it. Blend gently with a damp brush.
(11)

The Shoulder Soft Brown Rabbit

(12)

With a medium value mixture of Burnt Umber and White paint in the hairs on the shoulder. Put only a few strokes in the shadow areas to keep them dark. Make your strokes follow the direction of the hairs, being careful to lift up on the brush at the end of the stroke to make a fine tip. If you lose your darks go back over it with pure Burnt Umber.

(13)

Using a dark value, a mixture of Burnt Umber and Black, paint in some darker hairs under the head as in the illustration. Blend gently with a damp brush.

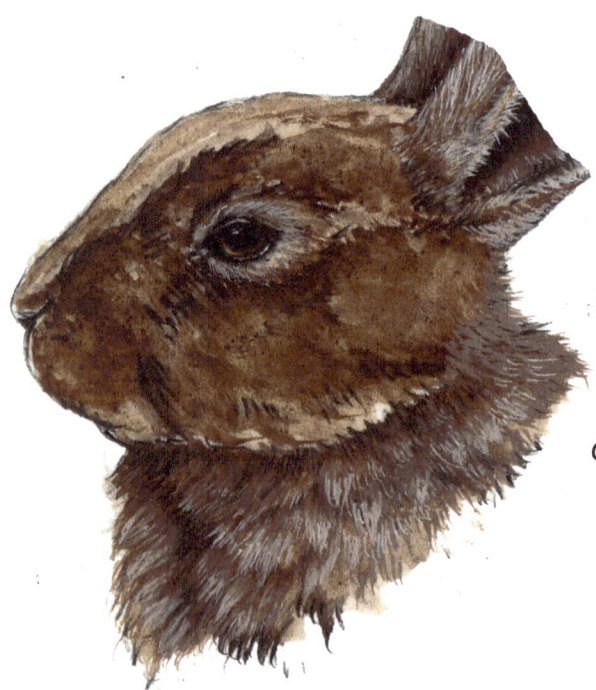

(14)

With White gouache paint in the top layer of hair. Watch the hair direction!. Gently blend with a damp bursh. The white will turn a light brown, but be sure to leave the tips of the hairs almost white.

Soft Brown Rabbit

The Head

(15) Using Burnt Umber paint in the dark hairs on the head. Be sure to follow the direction of the hairs in the fur.

(16) Add Black strokes to model the form of the rabbit's head as shown in the illustration. Gently blend with a damp brush. Don't completely wash out all the hairs. Just soften them.

(17) With White gouache detail the head by painting in the top layer of hairs, being careful to follow the direction of the hairs in the fur.

The Head — Soft Brown Rabbit

(18) With a damp brush gently blend the hairs. Don't be afraid to add more white or Burnt Umber as you go along if you lose too much of the dark or light values. When you blend in the shite it will become light brown. Keep adding more strokes of white and then blending until you get the desired effect, as shown in the illustration.

(19) To add the whiskers on the rabbit's left side put a small amount of white on your liner brush and lightly paint in the hairs. Don't make them too even. On the rabbit's right side whiskers use Burnt Umber mixed with White to lightly paint in the whiskers, lifting your liner brush at the end of the stroke to make the point of the hair.

Now take a minute to sit back and look at your painting. Make any adjustments you think are necessary.

Notes

Raccoon

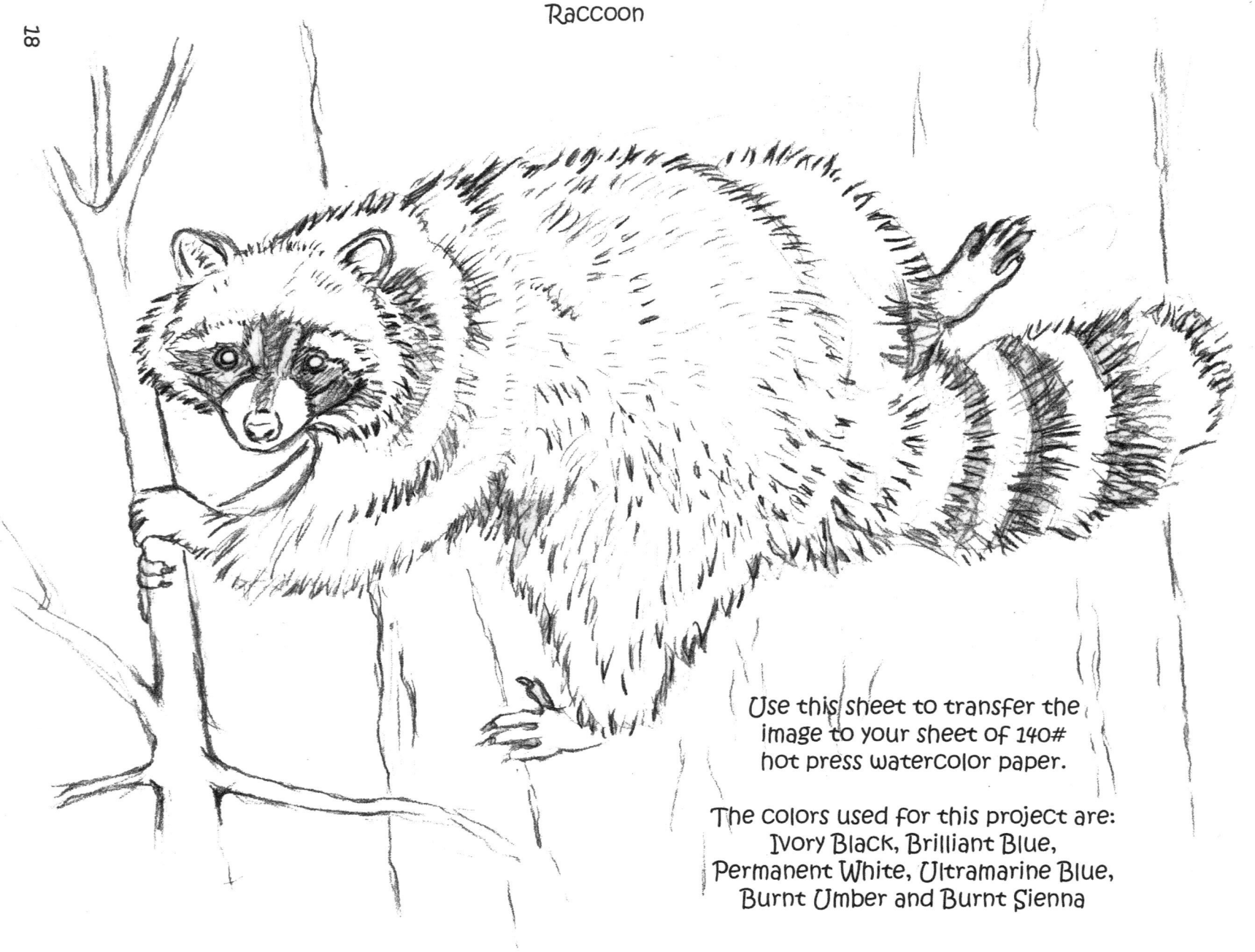

Use this sheet to transfer the image to your sheet of 140# hot press watercolor paper.

The colors used for this project are:
Ivory Black, Brilliant Blue,
Permanent White, Ultramarine Blue,
Burnt Umber and Burnt Sienna

Raccoon

Background

Colors Used: Ivory Black, Brilliant Blue, Permanent White, Ultramarine Blue, Burnt Umber, Burnt Sienna,

(1) Put in a minimum amount of background. Start with a mixture of Primary Blue and Permanent White for the sky, using more white as you get closer to the horizon.

(2) Paint the trees. Since the light is coming from the right side the lighter colors will be found there. Paint the shadow (left side) of the trees with a mixture of Burnt Umber and Ultramarine Blue.

(3) Paint the right side with a mixture of Burnt Umber and White. Remember that you're painting a cylinder shape.

Raccoon Background

(4) Begin blending where the dark side and light side meet. Detail the bark, adding black in the darkest crevasses. Add more white to the mix for the right side. Soften the outside edges of the trees with a damp brush.

(5) Continue detailing the bark on the trees, adding more lights and darks. Be sure to make a shadow under the raccoon with Black and Ultramarine Blue. Blend the edges of the bark a little.

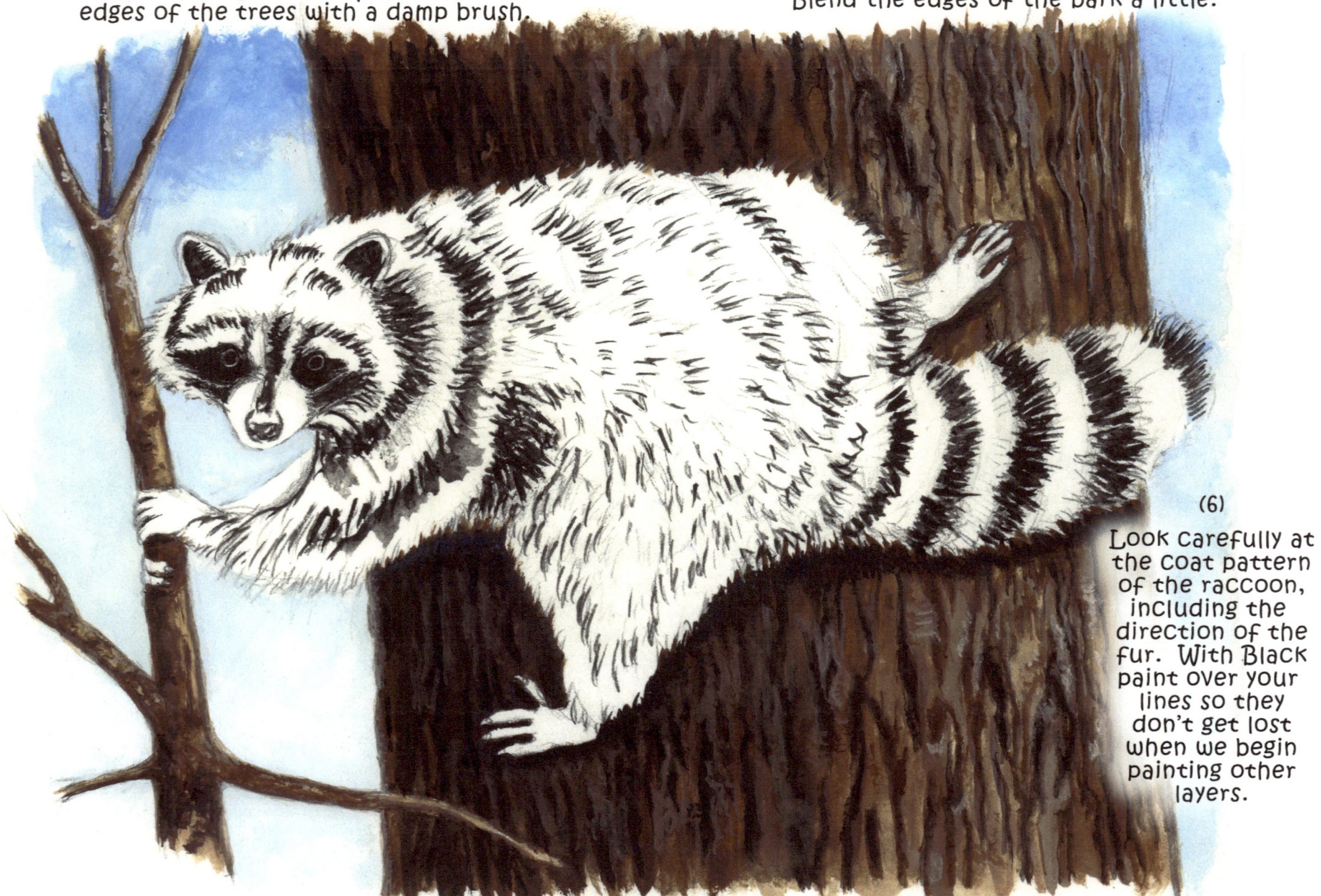

(6) Look carefully at the coat pattern of the raccoon, including the direction of the fur. With Black paint over your lines so they don't get lost when we begin painting other layers.

(7) Raccoon

With a medium gray (Black + White) paint in an underpaitning, stroking along the hair pattern with short strokes. Remember, this is just an underpainting. Don't be too precise. Start stroking on some pure black to model the body, head and tail. Again, use small strokes & follow the hair pattern. Leave the paws white for now.

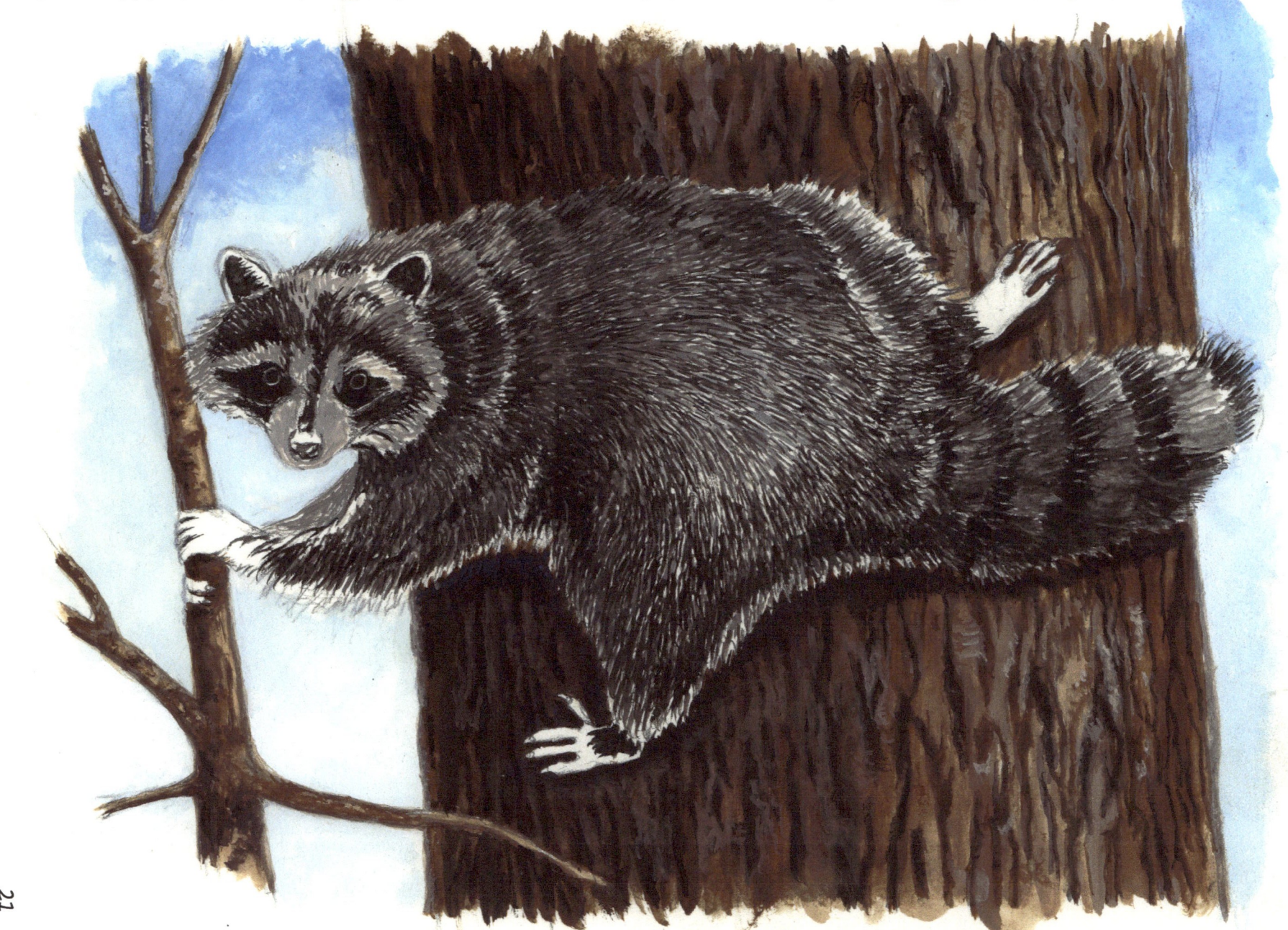

Raccoon Head

(8) **Black Mask & Eyes** - Start detailing the head. Make sure the eyes are very black. So they won't blend into the mask make a very thin light gray line on the upper and lower lids. With a medium value mixture of Primary Blue and White, paint the area under the eyes with short strokes. Blend with a damp brush.

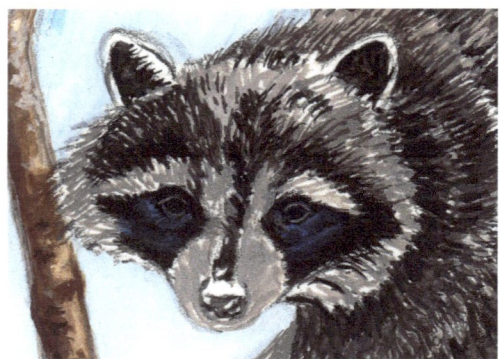

(9) **Eyes** - Using Burnt Sienna, put in a tiny curved line along the lower left edges of the eyes. Blend it in a little. Using a light mixture of Primary Blue and White (almost White) paint in a tiny highlight in each eye.

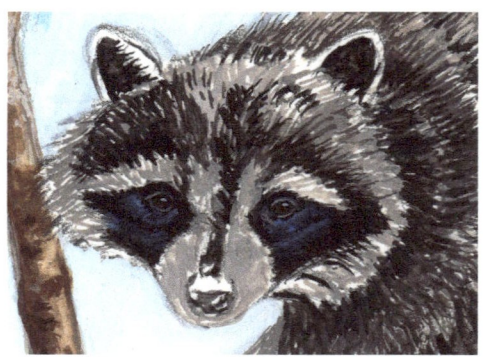

(10) **Ears** - Make sure you have a dark value painted on the inside of the ears -- a combination of Burnt Umber and Ultramarine Blue and a little Black. Using White, paint the white rim around the edge of the ears. The ear that has the sky behind it will be lost in the background unless you put a narrow dark gray line around it. Make sure the line is blended a little so it isn't too sharp. Using White, paint in the long wispy hairs in the ears.

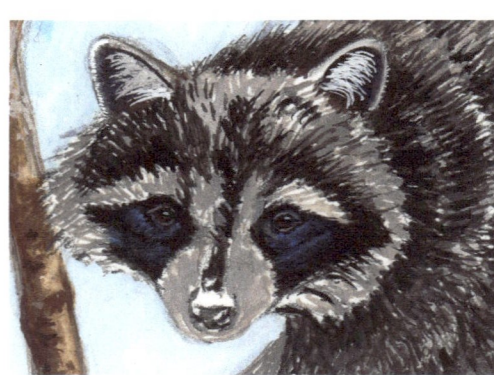

(11) Use a medium gray to shade the hairs in the ears. Gently blend with a damp brush.

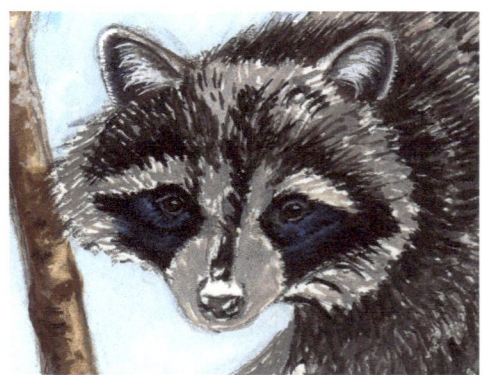

Raccoon Head

(12) Forehead -- With short brush strokes and a mixture of Burnt Umber and Ultramarine Blue, paint in the fur on the forehead. This first layer will be dark. Also, paint some of the fur on the outside edge of the cheeks. Eventually this part will be almost white.

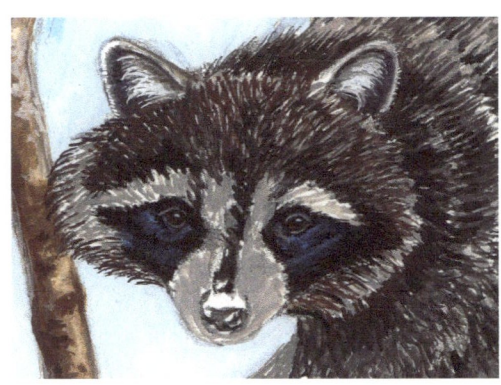

(13) Using light gray paint short strokes across the forehead, leaving some of the darker strokes you made before showing through.

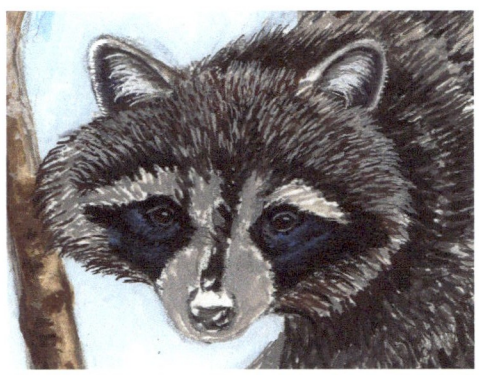

(14) Using Black, put in the last series of short strokes to detail the fur in the forehead. Gently blend the strokes a little to soften them. If you blur them too much just go over them again with dark and light values of gouache. With a little dark gray stroke in some hairs above the eyes and in the outside areas of the cheeks.

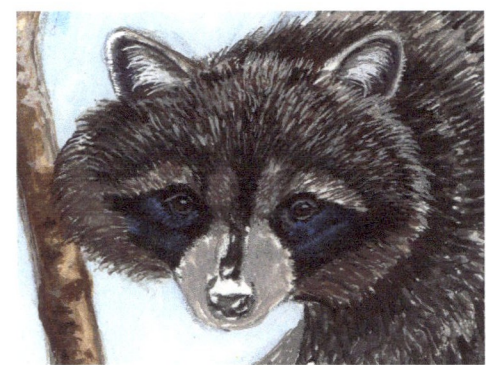

(15) The white patches over the eyes and on the cheeks -- Using White, paint in the lightest values above the eyes and on the cheeks. Don't completely cover the dark gray you painted previously. With a damp brush gently blend the strokes a little to soften them and blend them into the black mask.

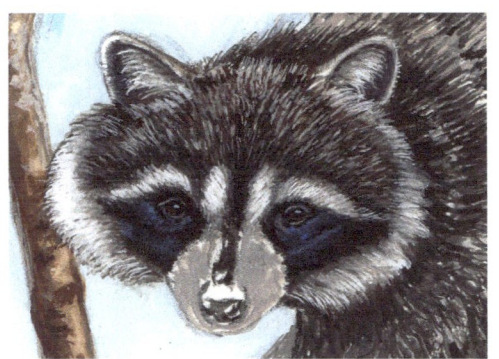

Raccoon Head

(16) Muzzle - With White gouache, paint over the gray of the muzzle with tiny strokes, letting some of the gray show through. Make your strokes in the direction of the hair. Under the chin paint it a little darker where the shadow will be, and to differentiate the chin from the blue of the background.

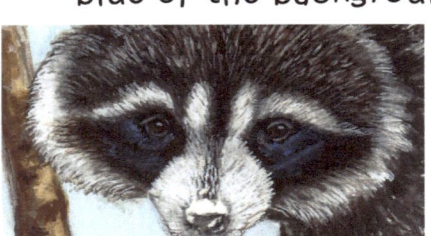

(17) With a damp brush, gently blend the white of the muzzle into the black of the mask. You may have to add more black or white strokes.

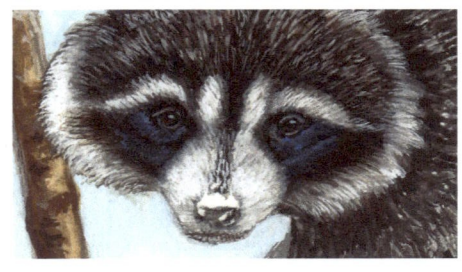

(18) With a mixture of Burnt Umber and Ultramarine Blue, use very short strokes to paint in the hairs in the dark strip down the center of the top of the muzzle. Blend.

(19) Using pure Black rough in the nose.

(20) Using a damp brush, blend the edges of the nose so it doesn't look pasted on. With Brilliant Blue mixed with white paint the top of the nose. Blend. With light gray put a highlight on the bottom rim of both nostrils. Using White gouache put a tiny highlight on the top of the nose on the right side.

Raccoon Body

(21) Go back to detailing the body. With a dark mixture of Burnt Umber and Ultramarine Blue, use short, narrow strokes to paint the body. Follow the hair pattern. Don't make your strokes too even or mechanical. If you start losing your darkest darks just put in some more black lines.

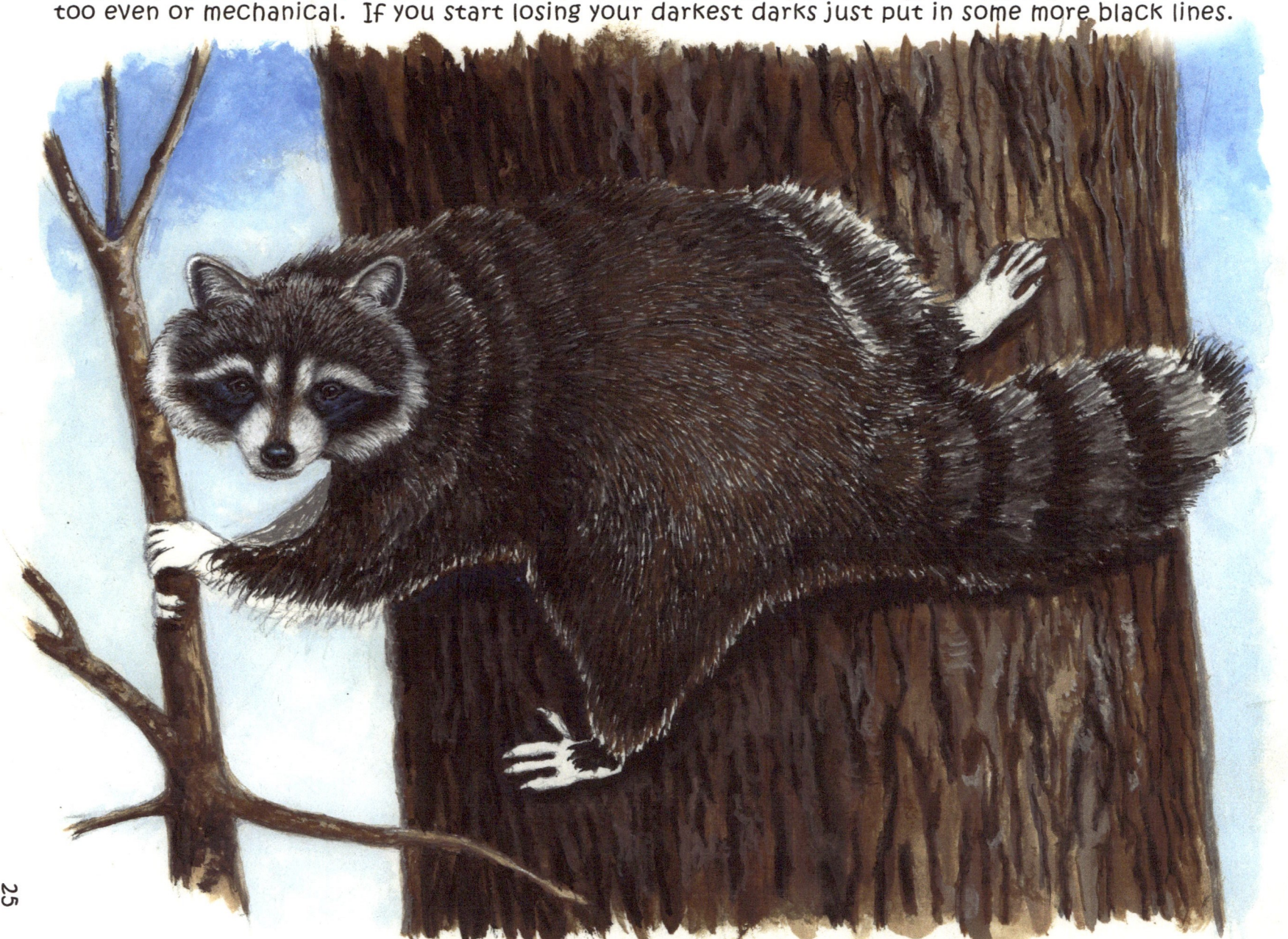

Raccoon — Body

(22) Using a liner brush and short strokes, paint in the light gray hairs using a mixture of White and a little Burnt Umber and Ultramarine Blue. Follow the contours of the body. If you find you've lightened an area too much, just go back over it with black or dark brown. Don't make your strokes too even -- make some a little longer or shorter and going in a slightly different direction.

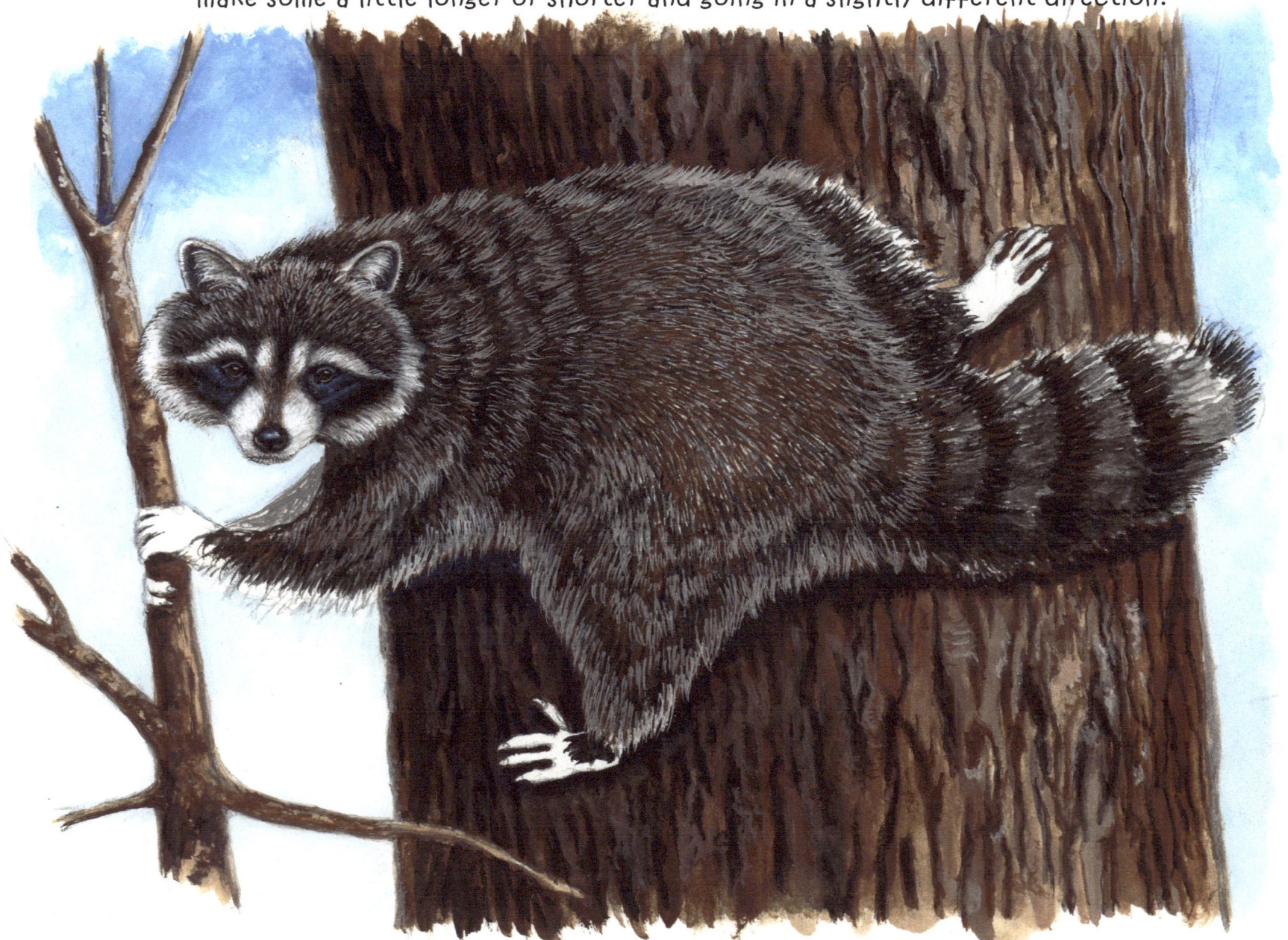

Raccoon Body

(23) This process takes a long time. Add light gray where the light hits the fur along the top and right side of the raccoon. As you go along gently blend a little to soften the hairs.

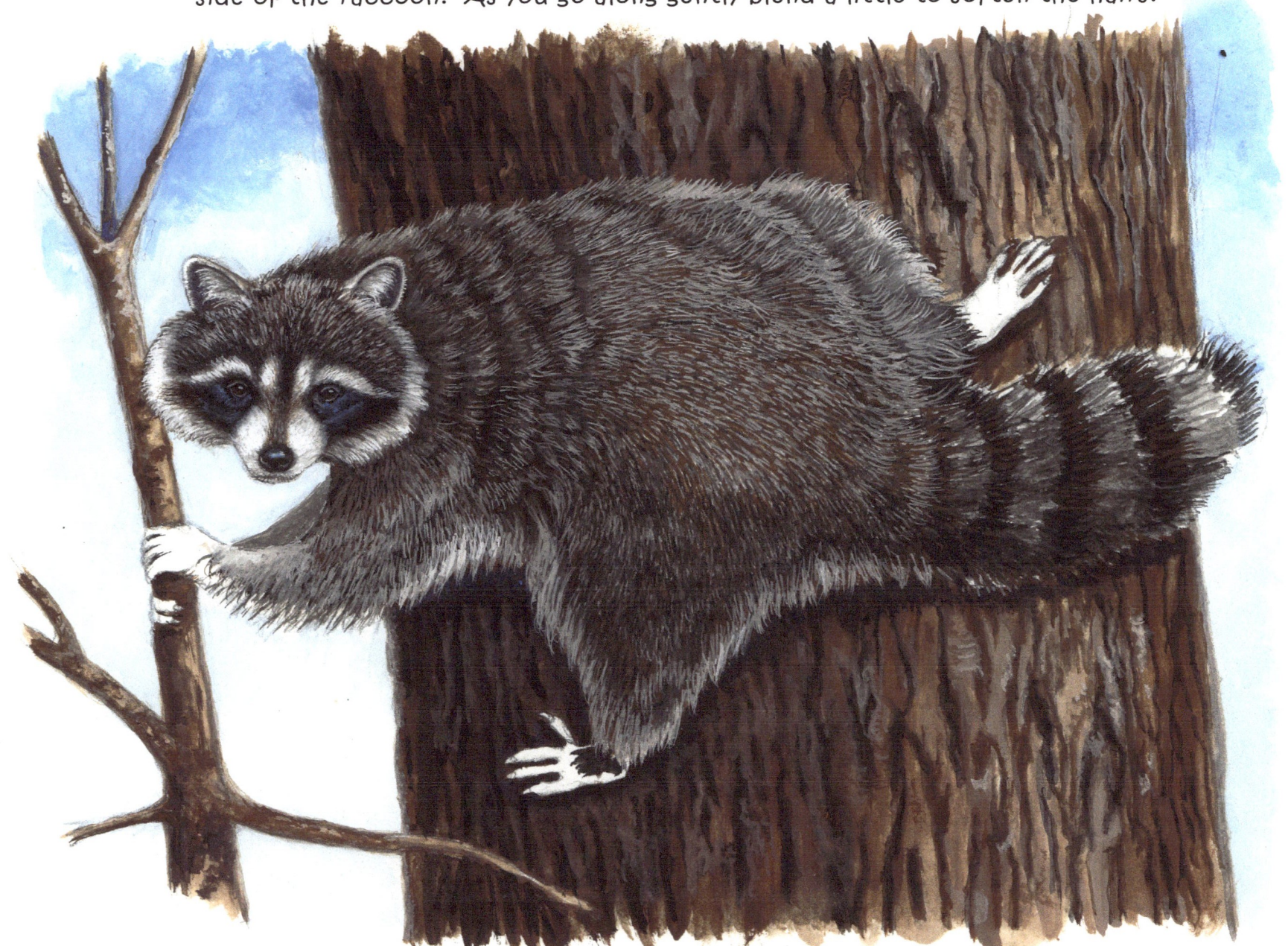

Raccoon — Front Legs

(24) On the front legs paint long, white hairs over dark gray. Blend a little with a damp brush.

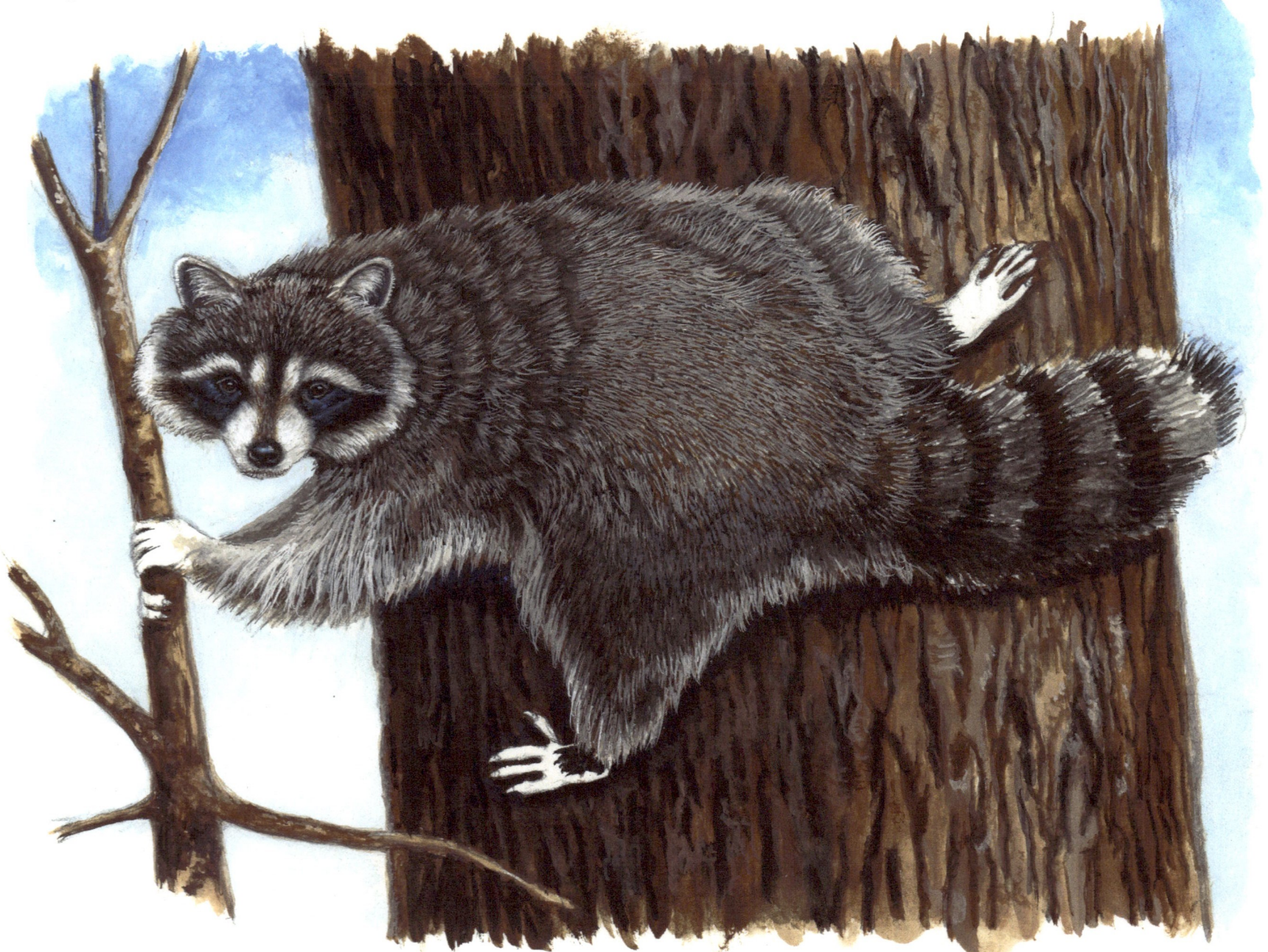

Raccoon Tail

(25)

With Black put in the dark rings on the tail.

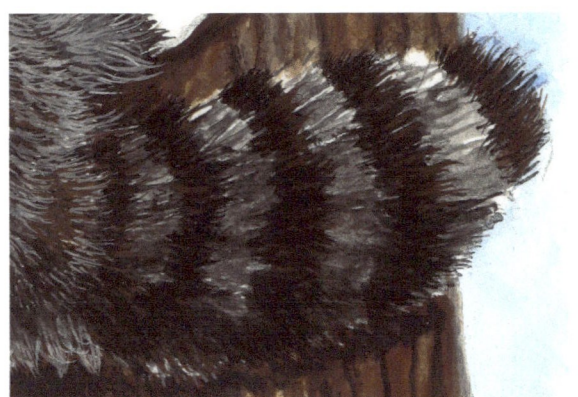

(26)

With a light gray roughly paint in the ight rings on the tail.

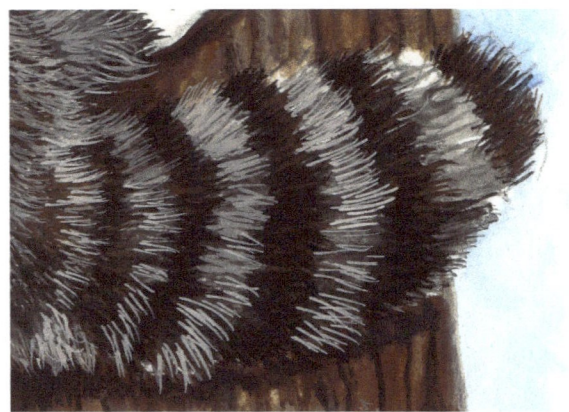

(27)

Shape the tail. Make sure all the hairs originate at the center (where the bone is) and flair outwards. Shade the underside of the tail with a dark gray on the white stripes. Use Primary Blue mixed with white to put a few highlights on the lower dark stripes. Gently blend the hairs together with a damp brush.

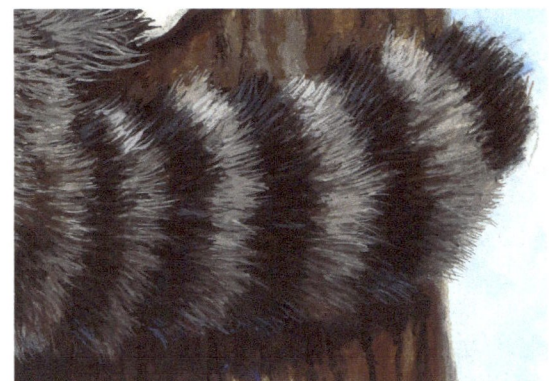

Raccoon

Paws

(28) Paint the paws with a thick, creamy layer of medium gray. Use either a mixture of White and Black, or White plus Ultramarine Blue and Burnt Umber. They both make grays.

(29) With dark gray put in the shadows on the toes and blend them in with the medium gray to get a 3D effect.

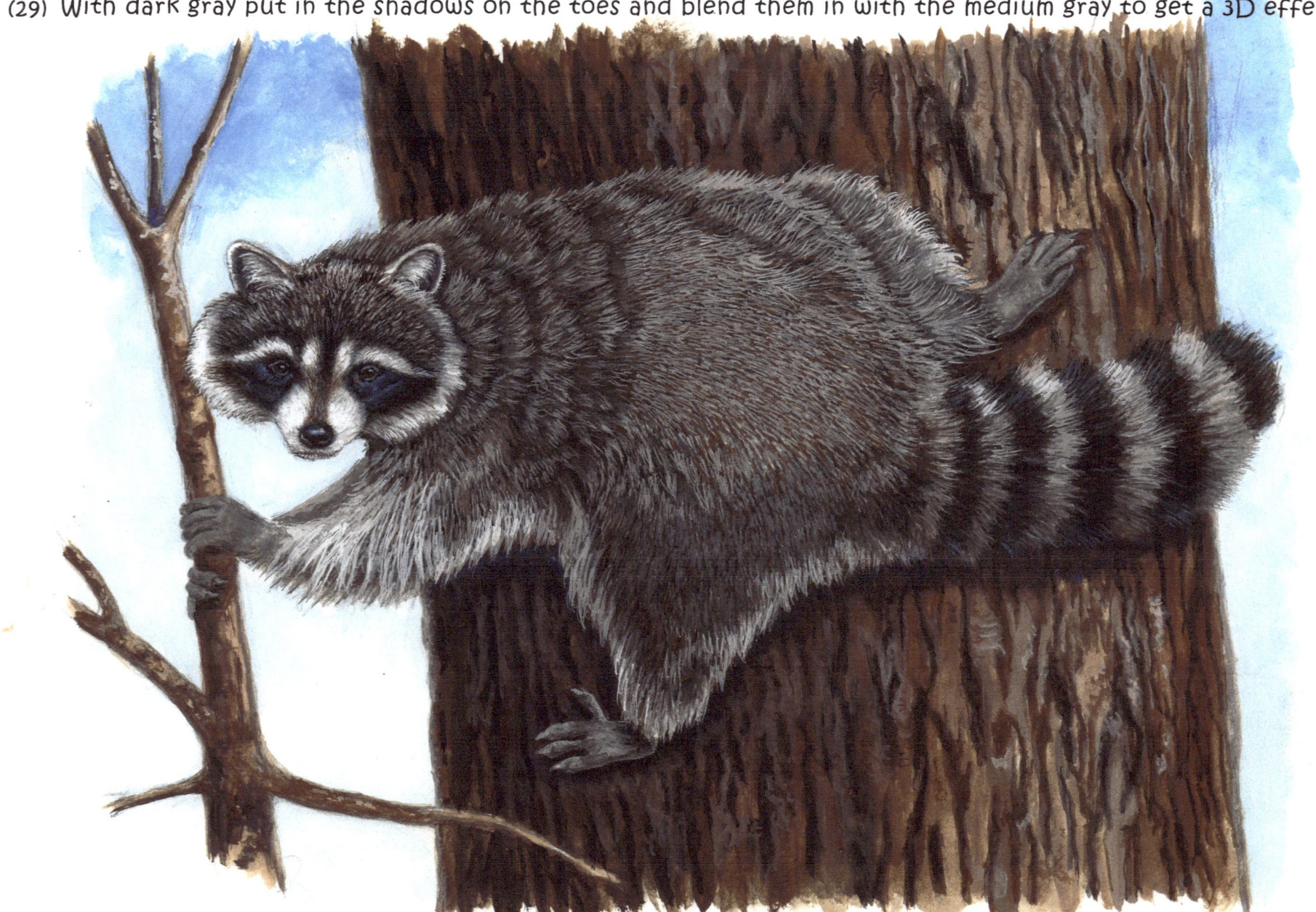

Raccoon — Paws & Whiskers

(30) With light gray finish detailing the paws, making short strokes in the direction of the fur and then gently blending..

(31) And, finally, put in some whiskers. Use white where the whiskers cross the dark fur of the raccoon, and gray where the whiskers cross the light sky. Also add some white strokes above the gray whiskers. These strokes are very narrow.

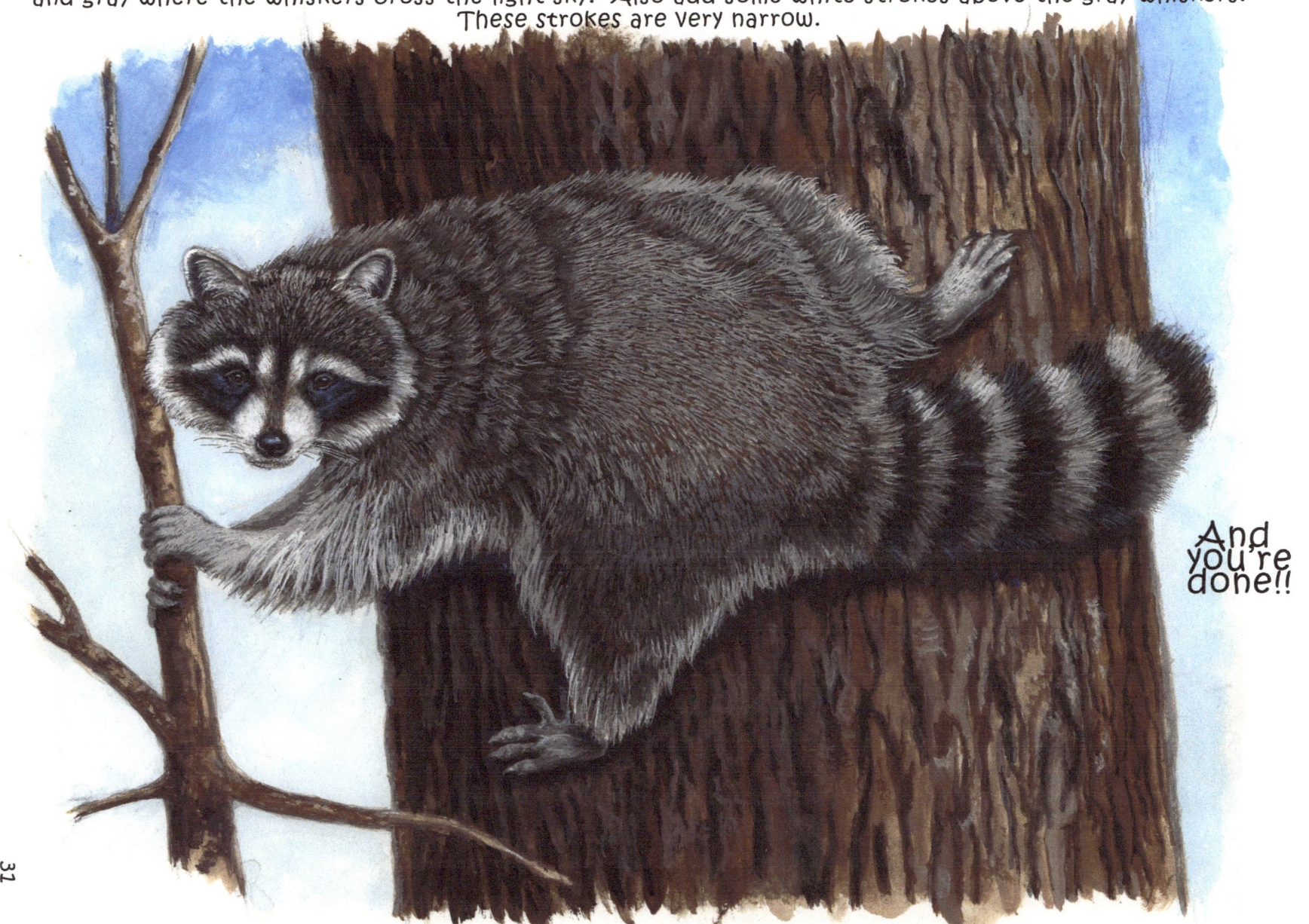

And you're done!!

Pinto Trail Horse

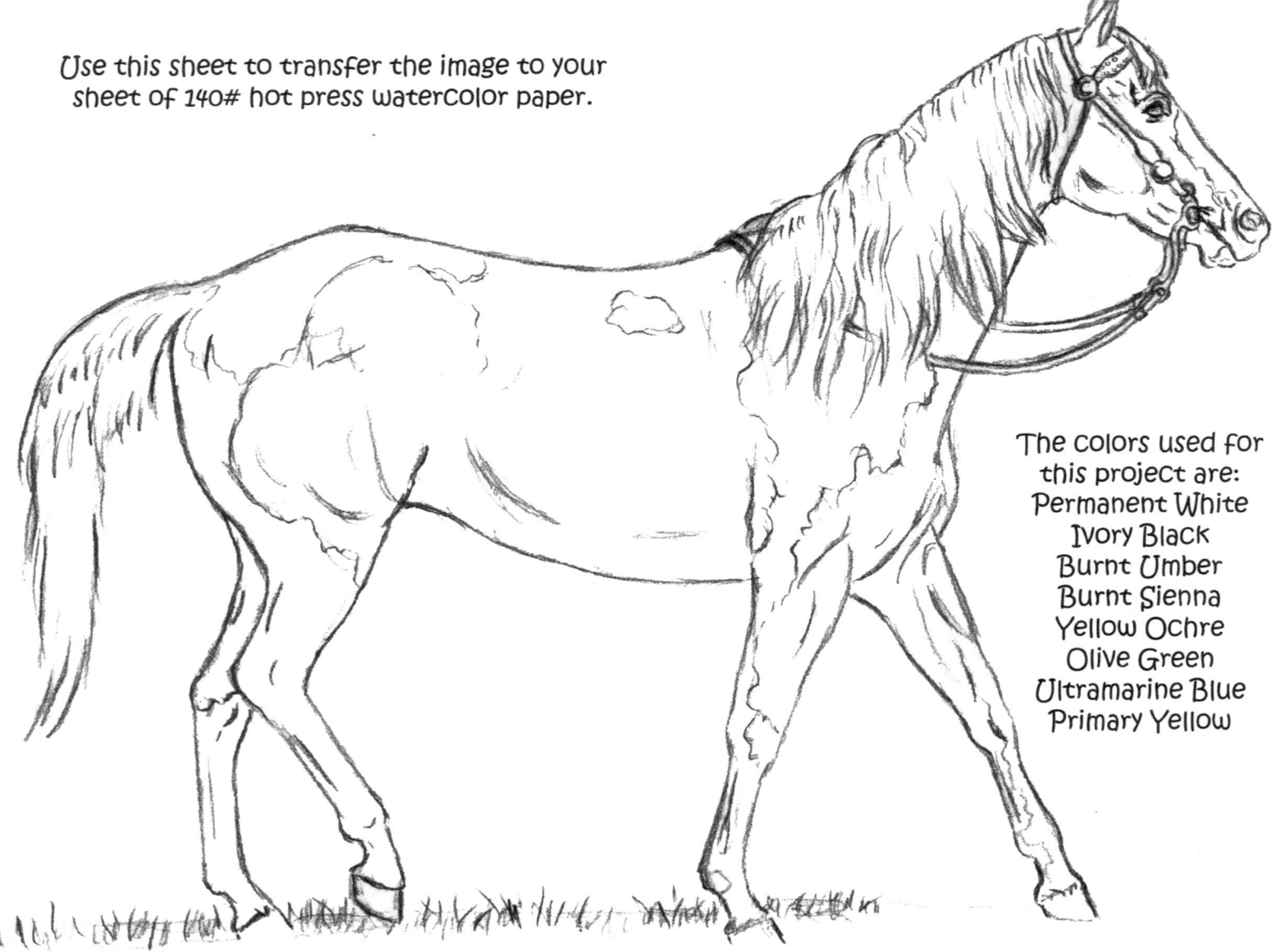

Use this sheet to transfer the image to your sheet of 140# hot press watercolor paper.

The colors used for this project are:
Permanent White
Ivory Black
Burnt Umber
Burnt Sienna
Yellow Ochre
Olive Green
Ultramarine Blue
Primary Yellow

Colors Used: Permanent White, Ivory Black, Burnt Umber, Burnt Sienna, Yellow Ochre, Olive Green, Ultramarine Blue, Brilliant Yellow

Pinto Trail Horse

(1) First, paint a narrow strip of shadowed grass below the horse's hooves so it won't appear to be "floating" in mid air. Backgrounds are generally painted in first so the edges of the animal can be painted over them. That way you won't have to be so careful painting in the background around an animal that's already finished. You'd definitely need some touch ups! With a mixture of Olive Green, Burnt Umber and Ultramarine Blue, paint in the blades of grass. Use short strokes and a small liner brush. Flick the brush upward to make the narrow tips on the blades of grass.

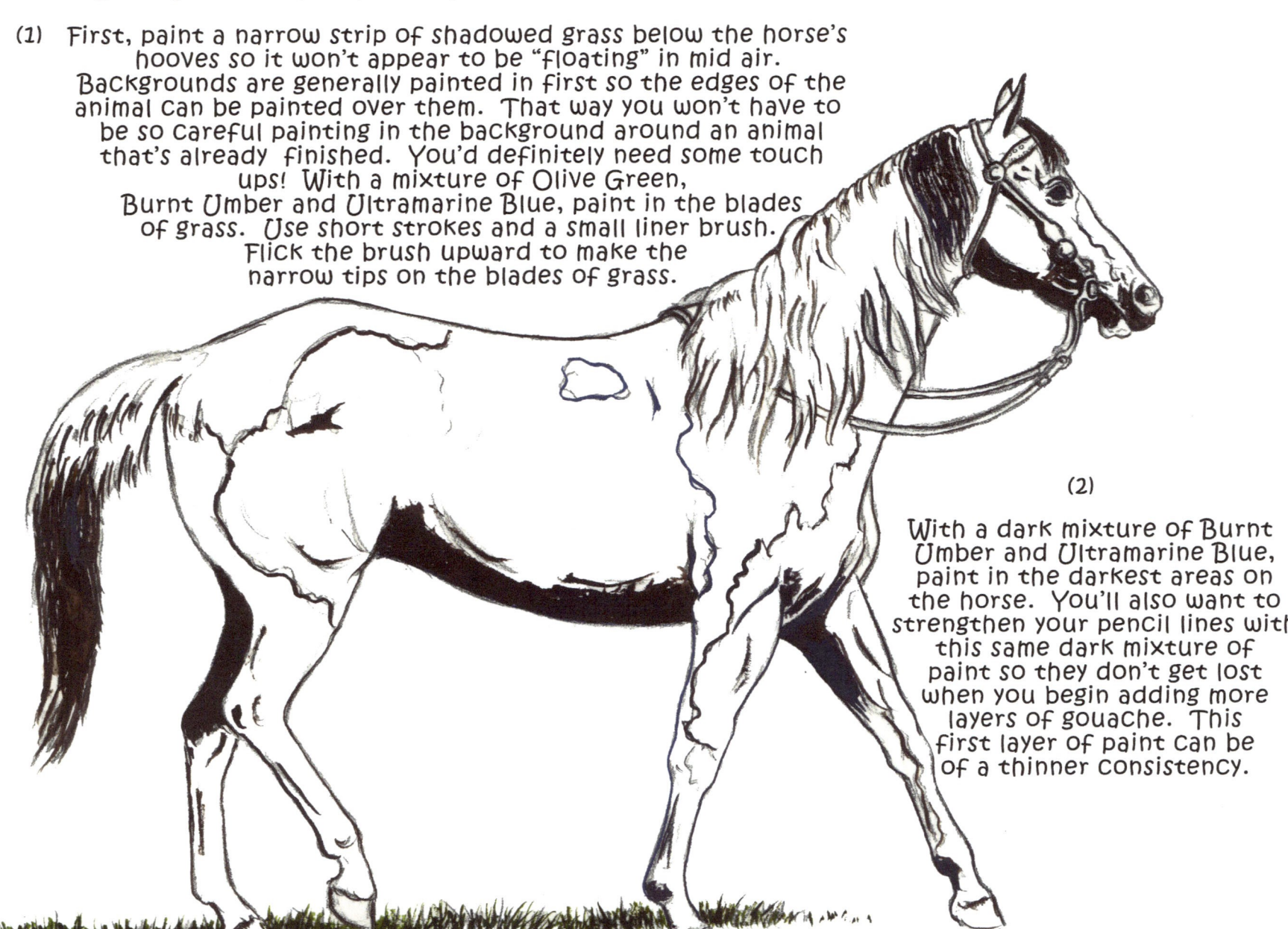

(2) With a dark mixture of Burnt Umber and Ultramarine Blue, paint in the darkest areas on the horse. You'll also want to strengthen your pencil lines with this same dark mixture of paint so they don't get lost when you begin adding more layers of gouache. This first layer of paint can be of a thinner consistency.

Pinto Trail Horse
Left Front Leg

From here on we'll be concentrating on one section of the horse at a time to make the demonstrations easier to understand. In a real situation you probbly wouldn't do it this way.

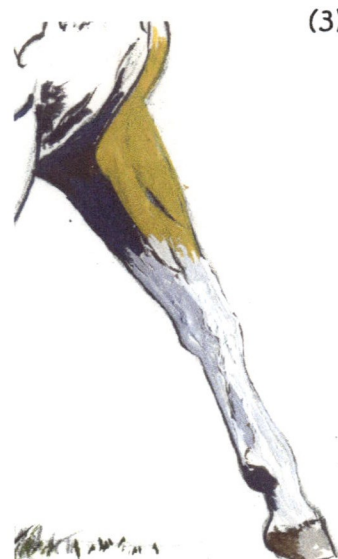

(3) Start with the left front leg, the one stretching forward. Mix Yellow Ochre and White and paint the right side of the upper leg. Using a dark value (mix Burnt Umber & Ultramarine Blue) paint the shadowed side of the upper leg. Add more white to this mixture and paint the side of the lower leg catching the light (right side) with a light gray. Paint the left side of the lower leg with a darker gray. Paint the hoof with Burnt Umber on the left side and Burnt Umber mixed with White on the right side. Paint right up to the edge of the dark outline, leaving only the tiniest sliver showing.

(4) Upper Leg -- With a damp brush blend the Yellow Ochre into the dark shadow on the left. You may have to add a little more of the lightened Yellow Ochre as you blend. With your dark value shade the dark muscle in the upper leg. Add a highlight with White on the right side. In the deepest shadow on the left side add a little Brilliant Blue mixed with White. Blend so you can barely see the reflected light. Blend and soften the outside edges of the upper leg.

(5) Knee, Lower Leg & Hoof --

With a dark gray mixture (Burnt Umber, Ultramarine Blue and White) detail the knee and lower leg as shown in the illustration.

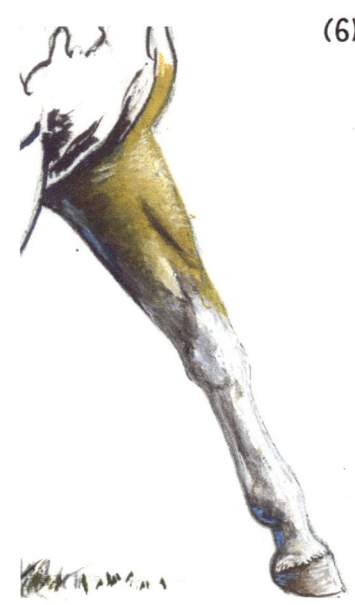

(6) Use White to highlight the right side of the leg. Blend the light and dark areas together with a damp brush. Don't forget to soften the outside edges so the leg doesn't look pasted on the paper. Put a highlight on the front of the hoof and blend the colors together. Put a tiny bit of Primary Blue ixed with White in the shadow on the left side of the ankle area (pastern) of the lower leg. Blend it in gently.

Pinto Trail Horse

Legs

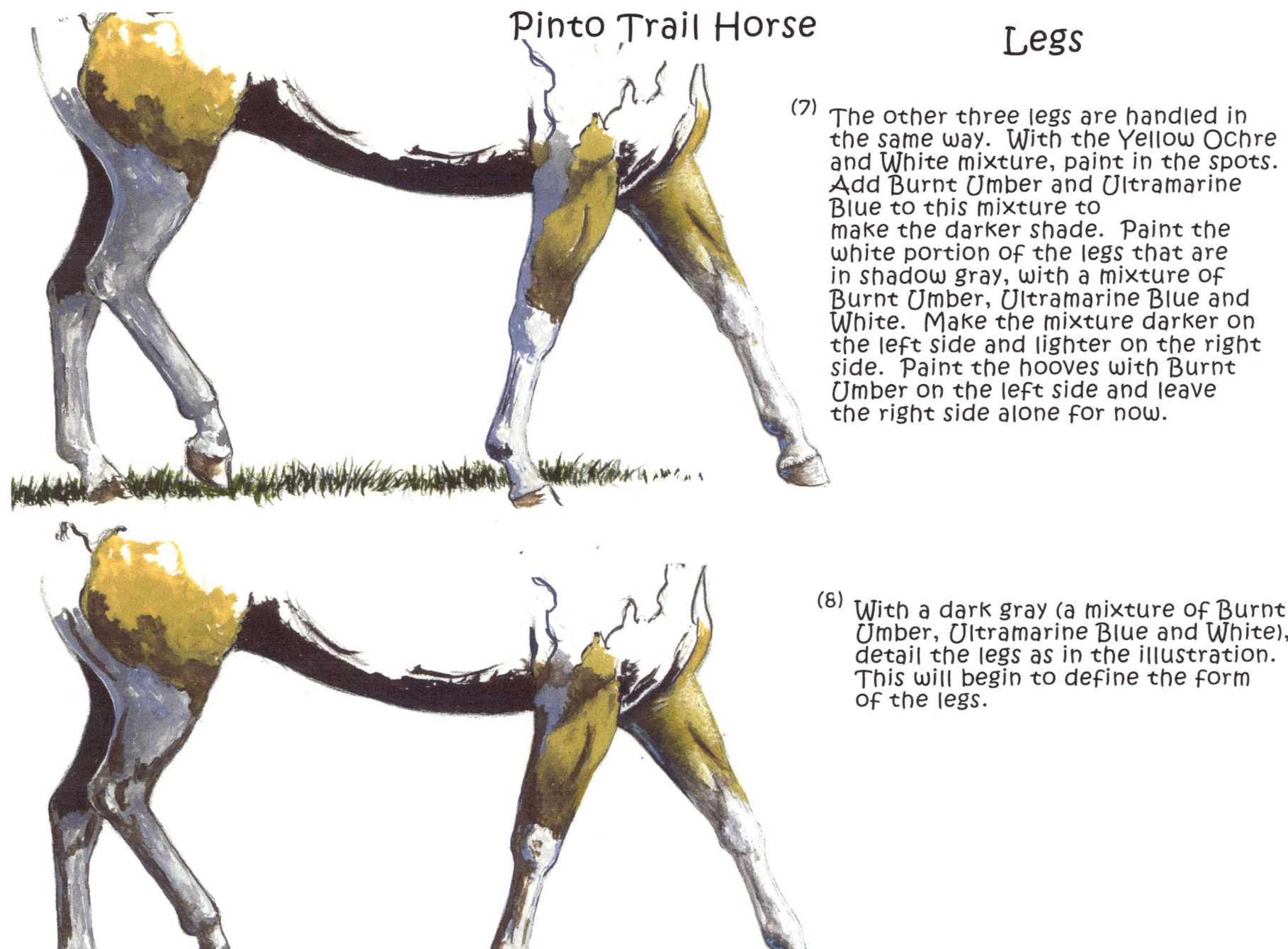

(7) The other three legs are handled in the same way. With the Yellow Ochre and White mixture, paint in the spots. Add Burnt Umber and Ultramarine Blue to this mixture to make the darker shade. Paint the white portion of the legs that are in shadow gray, with a mixture of Burnt Umber, Ultramarine Blue and White. Make the mixture darker on the left side and lighter on the right side. Paint the hooves with Burnt Umber on the left side and leave the right side alone for now.

(8) With a dark gray (a mixture of Burnt Umber, Ultramarine Blue and White), detail the legs as in the illustration. This will begin to define the form of the legs.

Pinto Trail Horse — Legs

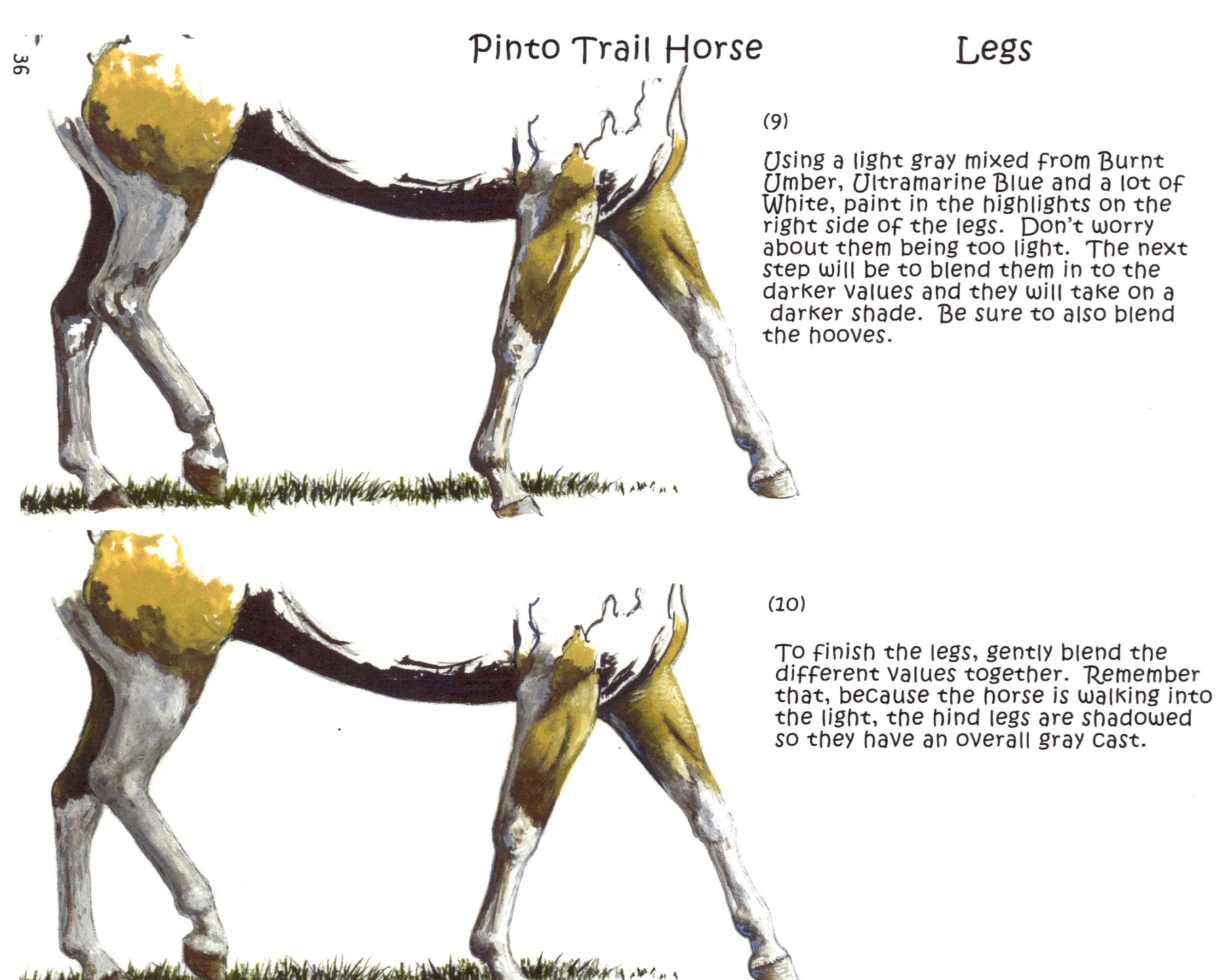

(9)

Using a light gray mixed from Burnt Umber, Ultramarine Blue and a lot of White, paint in the highlights on the right side of the legs. Don't worry about them being too light. The next step will be to blend them in to the darker values and they will take on a darker shade. Be sure to also blend the hooves.

(10)

To finish the legs, gently blend the different values together. Remember that, because the horse is walking into the light, the hind legs are shadowed so they have an overall gray cast.

Pinto Trail Horse

Head

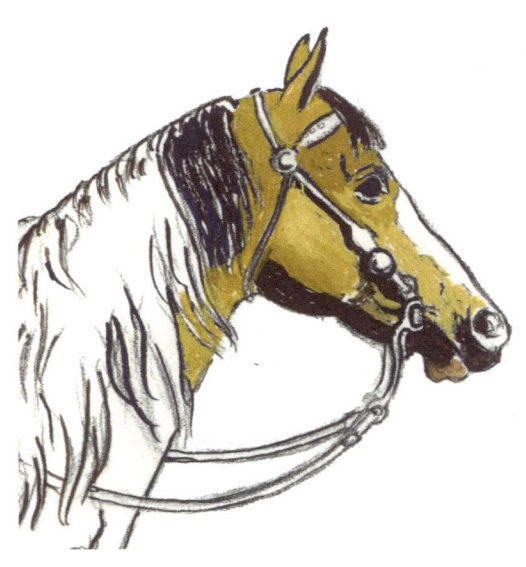

(11) Paint the horse's head with a mixture of Yellow Ochre and White, leaving a white blaze. Put a touch of thinned down Burnt Sienna on the lower lip and chin.

(12) Blend the Yellow Ochre into the dark shadows you painted previously. Add more Yellow Ochre to lighten the area a bit if blending makes it too dark. Use Burnt Umber to detail the head, adding more shadows and defining the planes of the head. Blend gently.

(13) Continue to use Burnt Umber to detail the head. The trick is to BLEND with a damp brush. If you blend too much just add more Burnt Umber or Yellow Ochre and readjust. Be sure to paint in the shadows alongside the bridle.

Pinto Trail Horse Head

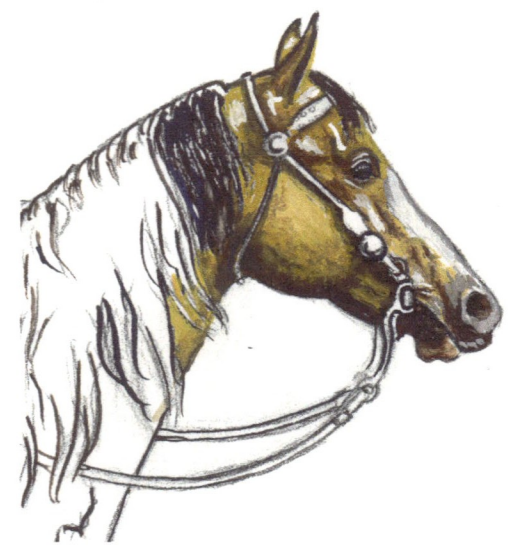

(14)

To highlight the head add white as in the illustration, along the side of the head and above the eye. After blending it will change to a light Yellow Ochre. Paint the blaze white but leave the dark edge along the bridge of the nose. Add some gray gouache to the muzzle.

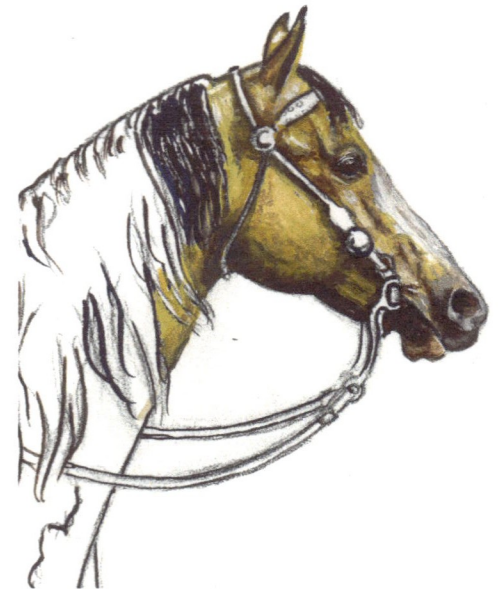

(15)

Now blend gently with a tiny damp brush. Add a touch of Burnt Sienna to the lower part of the iris and a tiny white highlight. The eye is so small there isn't much detail. Be sure to highlight the upper and lower rims of the eyelids where the light strikes them.

Pinto Trail Horse

Body

(16) With a mixture of Yellow Ochre and White, paint the golden portions of the neck and body. Don't worry about getting an even tone. Just cover up the white of the paper. The first layer of paint can be a little thin.

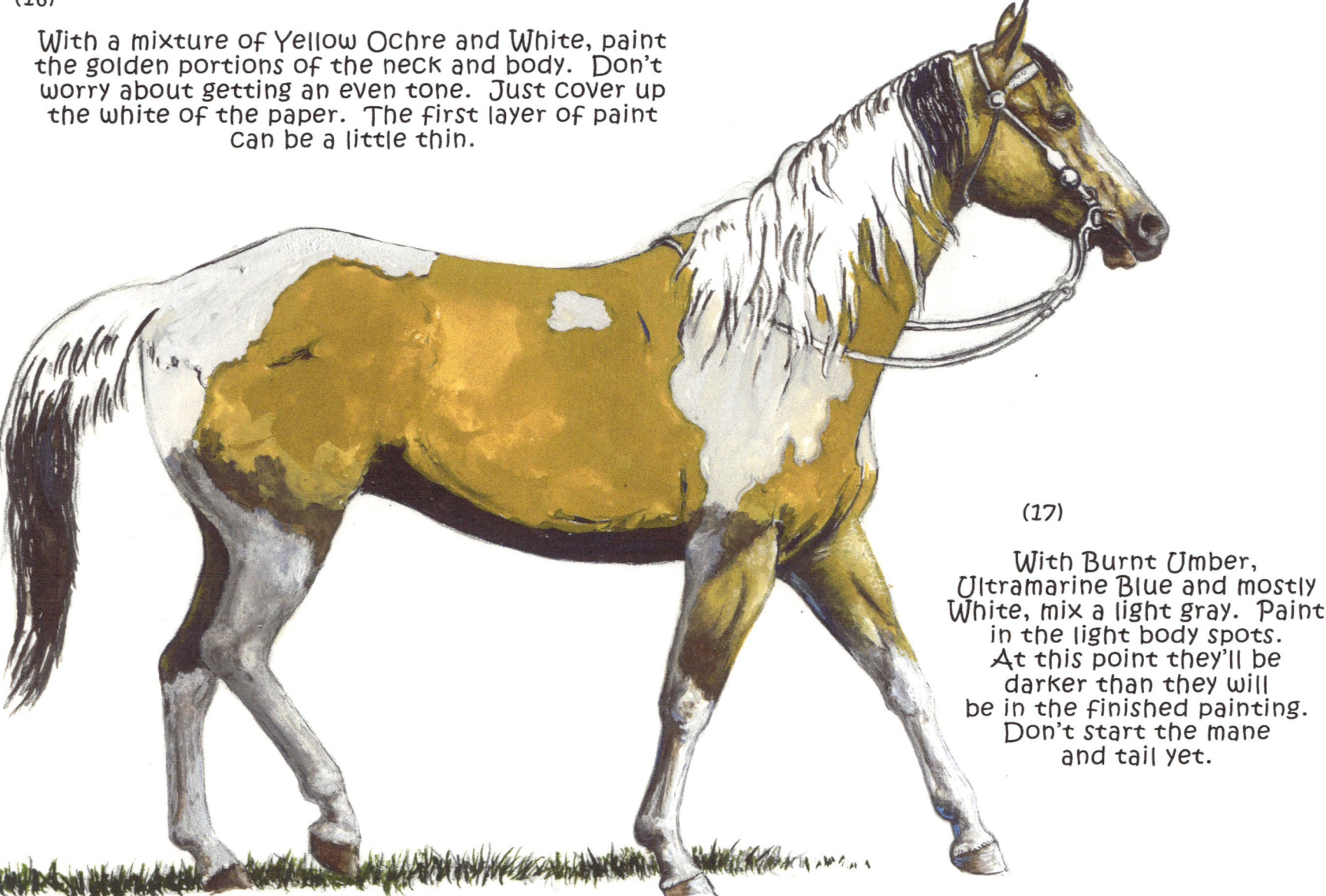

(17) With Burnt Umber, Ultramarine Blue and mostly White, mix a light gray. Paint in the light body spots. At this point they'll be darker than they will be in the finished painting. Don't start the mane and tail yet.

Pinto Trail Horse — Body

(18) Shade in the light spots. Since the light is coming from the upper right it will strike the portions of the white spots on top of the muscles. Those parts of the spots will be white, while the parts not in the light will be gray. This layer of paint will be a creamy consistency. Be sure to leave the thinnest bit of dark showing along the top line of the horse so the white spot won't fade into the paper. Use various values of gray (Burnt Umber, Ultramarine Blue and White) to "sculpt" in the muscles. Don't use long strokes. Dab the thick paint on and then blend. With a damp brush gently blend the edges where the white spots meet the Yellow Ochre. Put dark shadows on the neck below the mane.

(19) Finish painting the Yellow Ochre body color. Begin by blending the Yellow Ochre into the shadow under the horse's belly. Add more Yellow Ochre gouache, in a thicker layer, to do the blending. Add more shadow color (Burnt Umber and Ultramarine Blue) on the back right leg above the white spot and blend it upward into the Yellow Ochre. Add white along the top of the back and blend down into the Yellow Ocre for a highlight. Make dark shadows on the neck under the mane. Blend in a highlight on the front of the neck. Don't make long strokes. Dab the thick paint on and then BLEND. Soften the edges where the Yellow Ochre meets the white spots. Mix Brilliant Blue with White and paint a narrow line of reflected light in the dark shadow under the belly. Blend.

Pinto Trail Horse

Tail

(20)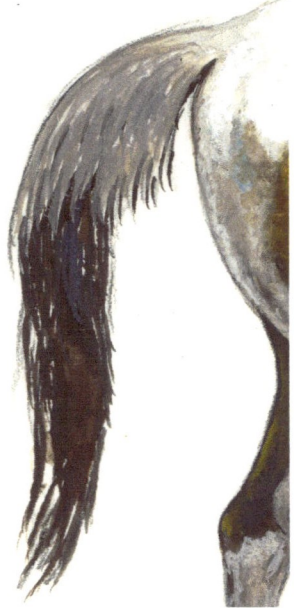
Paint the upper portion of the tail medium gray, with a mixture of Burnt Umber, Ultramarine Blue and White.

(21)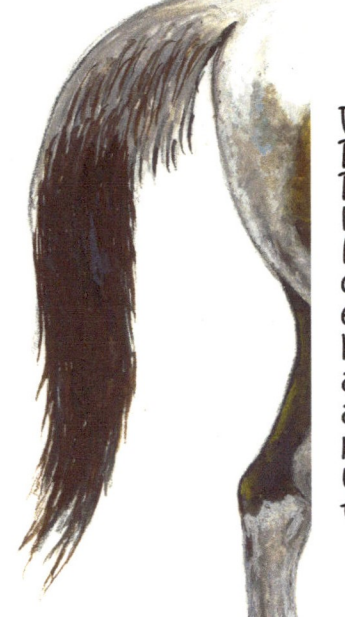
With a dark gray mixture of Burnt Umber, Ultramarine Blue and White, paint in the lower section of the tail. Make long strokes going downward, and toward the end of the tail "flick" the brush as you lift it to make a very thin line for the hairs at the tip of the tail. Also, paint some dark lines on the upper, lighter portion of the tail, following the hair pattern.

(22)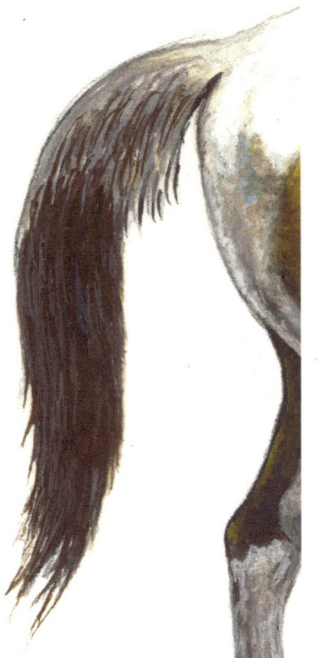
To complete the lower section of the tail, add a very small amount of white to your dark gray mixture. Using long narrow strokes with your liner brush, detail the tail. Blend gently. Soften the outside edges with a damp brush.

(23)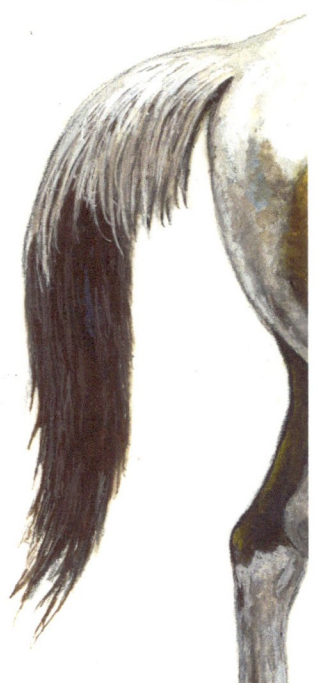
To finish the top part of the tail, use White in long narrow strokes to paint in the hairs. Paint some light gray hairs on the side and gently blend them together with a damp brush.

Pinto Trail Horse

Bridle

42

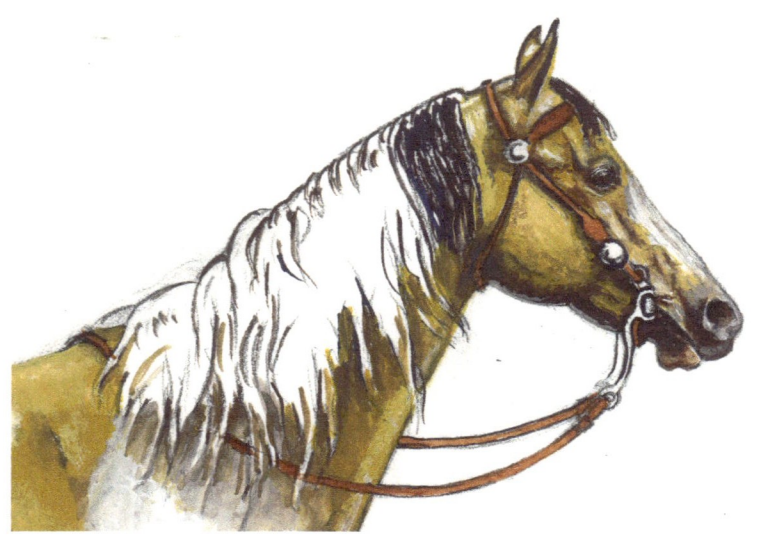

(24) Paint the bridle and reins with a thin layer of Burnt Sienna, being sure to leave the conchos and bit white.

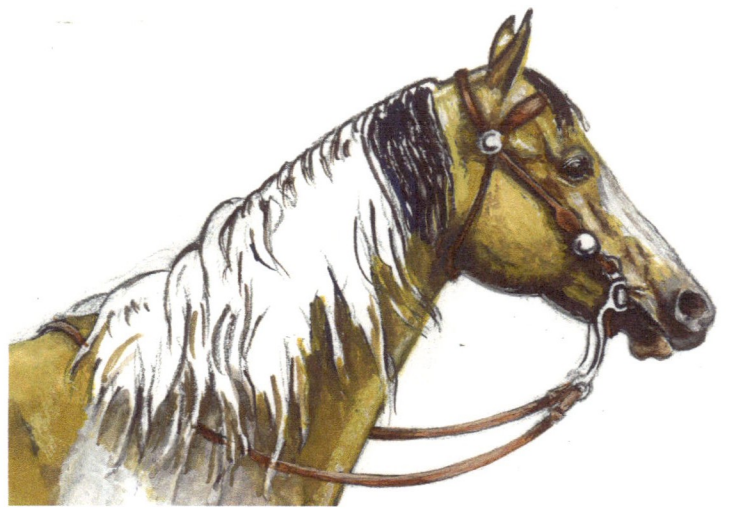

(25) Use Burnt Umber to shade the bridle and reins and then add white for highlights. Be sure to blend as you go along so the white will become a touch brown.

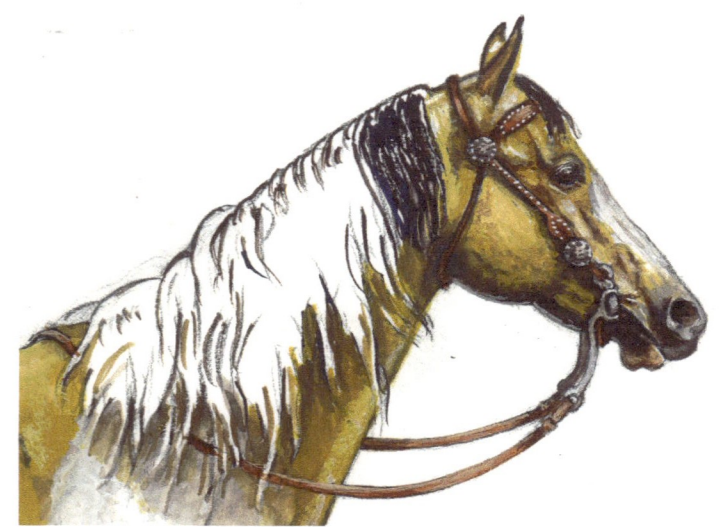

(26) Add tiny white dots to detail the bridle. Use white to make the conchos round, since they probably were partially painted over. Detail them with a dark gray mixture. Paint the bit a light gray and highlight it with white. Blend gently. These areas are very small.

Pinto Trail Horse

Mane

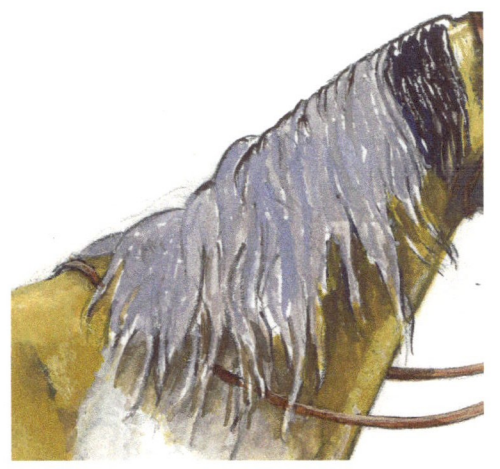

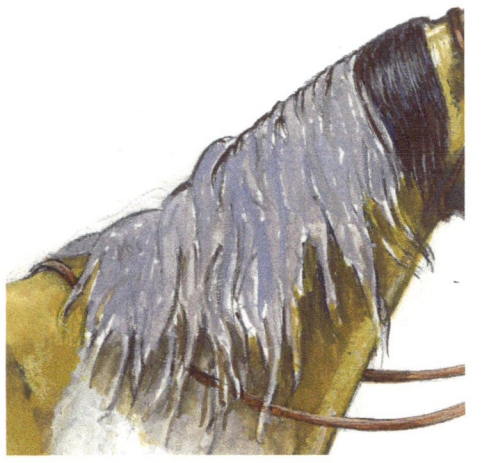

(27) Paint the mane a medium gray (except for the part that you painted with a very dark value previously).

(28) Detail the dark part of the mane nearest the head. With very fine, long strokes paint some of the hairs of the mane a dark gray. Go over it again with a dark value of Burnt Umber Umber mixed with Ultramarine Blue, leaving some of the gray showing. Use white to make the highlights. Gently blend the hairs together a little to soften them.

(29)

With pure White, paint fine, narrow strokes to depict the hairs in the mane. Make them curve a little instead of going straight down. Let some of the gray show through. When you end your stroke flick the brush upward to make the tips of the hairs. Then gently blend with a damp brush to soften the areas. Note that there is a ridge of white highlight along the top edge of the mane.

Pinto Trail Horse

Finish Up!

(30) Add a little grass across the bottom with a mixture of Olive Green and Primary Yellow, just to brighten things up a little.

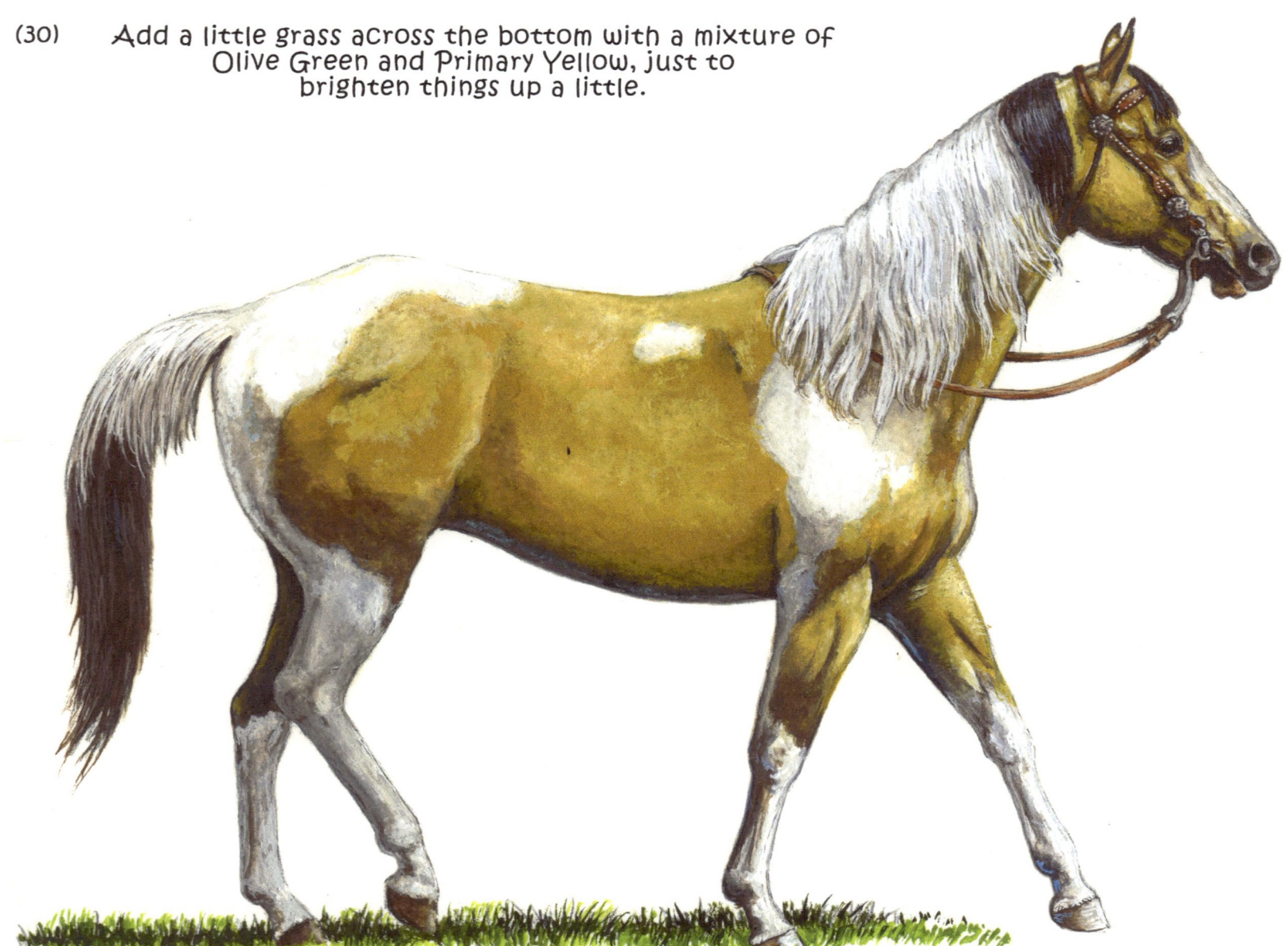

Wrapping Things Up!

Painting glistening eyes and flowing hair and fur is fascinating. I hope I've inspired you to continue to explore all the possibilities of using gouache to paint animals. An octogenarian friend of mine, an accomplished artist, once told me that every time you pick up a brush it's a learning experience. May you have many!

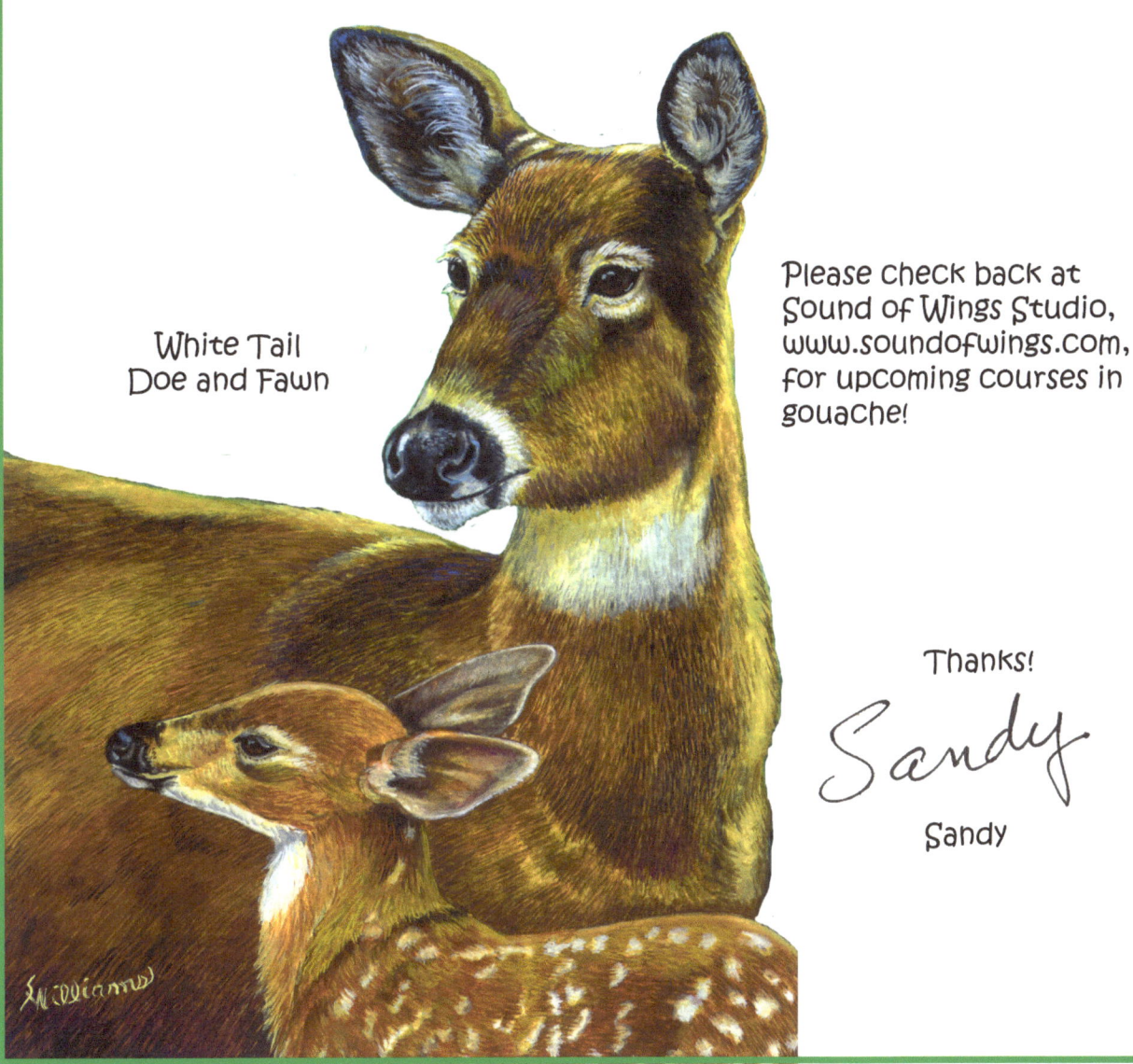

White Tail Doe and Fawn

Please check back at Sound of Wings Studio, www.soundofwings.com, for upcoming courses in gouache!

Thanks!

Sandy

Sandy

Notes

www.ingramcontent.com/pod-product-compliance
Lightning Source LLC
Chambersburg PA
CBHW040746200526
45159CB00023B/1751